Robins Williams 2024

LAUGHING IN THE DARK

THE EVOLUTION OF ROBIN WILLIAMS

VINCENT T HENSLEY

Robins Williams 2024

Laughing in the Dark

The Evolution of Robin Williams"

By

Vincent T. Hensley

Robins Williams 2024

All right reserved. No part of this publication may be reproduced, distributed, or transmitted in any form or by any means, including prototyping, recording or other electronics or mechanical methods, without the prior written permission of the publisher except in the case of brief quotation embodied in critical review and specific other noncommercial uses permitted.

Copyright© Vincent T. Hensley

Robins Williams 2024

Table of contents

INTRODUCTION

Statement of Robins Williams' Thesis

CHAPTER 1

Early Glimpses of Brilliance

Birth and Family Heritage

Youthful Curiosity

Education and Early Dreams

CHAPTER 2

The Making of a Comedic Legend

First Steps in Comedy

CHAPTER 3

Conquering Hollywood

1980s Success

1990s Golden Era

The 2000s and Beyond

Robins Williams 2024

CHAPTER 4

The Man behind the Laughter

Personal Life Unveiled

Battles and Triumphs

CHAPTER 5

Accolades and Applause

Academy Awards

Golden Globes, Emmys, and Grammys

Critical and Popular Acclaim

CHAPTER 6

A Heart of Gold

Charitable Ventures

Champion of the Troops

CHAPTER 7

The Twilight Struggle

Health Battles

Enduring Spirit

CHAPTER 8

A Tragic Farewell

Moral and lesson learned

INTRODUCTION

Enter a world where the unusual becomes commonplace, where there are no limits to laughing, and where every minute is an adventure. Welcome to the fascinating world of Robin Williams, where heart, humor, and absolute genius join together to create a narrative symphony unlike any other.

Get ready to be enthralled by the extraordinary life and legacy of a genuine legend on this captivating adventure. The tale of Robin Williams, from his modest origins to his quick ascent to fame, is a monument to the strength of humor, fortitude, and the human spirit.

Come along as we examine the early flashes of genius that turned a young Chicagoan youngster into a comic powerhouse. Prepare yourself for a fast-paced journey through the highs and lows of one of Hollywood's most cherished legends, from his outstanding performances on the small screen to his iconic parts on the big screen.

However, this is more than simply a tale of wealth and celebrity. It's a story about overcoming hardship, love, grief, and the resiliency of the human spirit. Learn about the man behind the laughs, his challenges, his victories, and the lasting impact he had on the globe.

So take a seat, fasten your seatbelt, and get ready to be moved, motivated, and delighted in ways you never would have imagined, dear reader.

Statement of Robins Williams' Thesis

The thesis statement, which summarizes Robin Williams' life and legacy, is a moving reminder of the significant influence his contributions have had on society at large and the entertainment business in particular. It claims that in addition to being a comic genius, Robin Williams was a versatile artist whose performances crossed genre and media boundaries and had a lasting impression on audiences throughout the globe.

Hailed as one of the most talented comedians and performers of his time, Robin Williams enthralled audiences with his unmatched wit, limitless energy, and

astounding flexibility. From his breakthrough performance in the television series "Mork & Mindy" as the irreverent alien Mork to his iconic roles in movies like "Good Morning, Vietnam," "Dead Poets Society," and "Mrs. Doubtfire," Williams demonstrated a unique ability to move between comedic and dramatic roles, winning praise and admiration from both fans and colleagues.

Beyond his extraordinary skill as an entertainer, Robin Williams had a significant influence on the big screen. His dedication to changing the world was shown by his charitable endeavors, generosity, and support of a number of issues, such as mental health awareness and assistance for people experiencing homelessness. Williams's readiness to be transparent about his battles with depression and addiction de-stigmatized these conditions and inspired others to go for assistance.

The thesis statement does, however, also recognize the complexity and difficulties Williams encountered in his personal and professional life. He battled inner demons and personal challenges, like drug misuse and mental

health concerns, despite his enormous success and acclaim. These factors eventually culminated in his terrible death in 2014. This acknowledgment of Williams's humanity and frailty highlights the value of compassion, empathy, and understanding in our judgments of public people and gives Williams' legacy more depth and complexity.

The thesis statement essentially states that Robin Williams's legacy is determined by his humanity, compassion, and fortitude in the face of hardship, in addition to his extraordinary skill and accomplishments as an entertainer. His performances can make people laugh, cry, and reflect, and his persistent dedication to changing the world serves as permanent reminders of the transformational power of art and the ongoing legacy of one of entertainment's most cherished and renowned individuals.

CHAPTER 1

Early Glimpses of Brilliance

Robin Williams's early flashes of genius provide an intriguing look into the creative energy and unlimited talent that would characterize his brilliant career in comedy, acting, and entertainment. From his early years as a young child growing up in a suburban Chicago neighborhood to his rise to prominence as a comic powerhouse on the international scene, Williams showed a rare combination of wit, improvisational skill, and audience-connecting innateness.

Robins Williams 2024

From a young age, Williams had a flair for comedy and performance, often amusing his family and friends with his sharp wit and hilarious antics. Growing up in a loving and supportive environment, Williams was encouraged to follow his artistic interests and hone his unique skills, which set the foundation for his future success in the entertainment sector.

In his early years, Williams showed a natural talent for humor and improvisation, providing one of the first indications of his intelligence. Williams was a natural performer from an early age, winning over audiences with impressions, comic routines, and lively storytelling, according to testimonies from his family and friends. His unbridled enthusiasm, contagious laugh, and unstoppable charisma won over everyone he met and hinted at the larger-than-life character that would eventually enthrall audiences worldwide.

Williams' love of performing only grew as he approached puberty, inspiring him to look for chances to polish his skills and show off his abilities. He started participating in school theater plays, where his comic

timing and acting flexibility wowed the crowds. Williams stood out from his contemporaries due to his ability to embody a broad variety of personalities and identities, from comedic clowns to Shakespearean monarchs, suggesting the depth and complexity of his skill.

Williams displayed not just his skill on stage but also his sharp mind and interest in the world around him. His passion for words and narrative thrived in disciplines like English and literature, where he excelled academically. Williams's artistic endeavors and exploration of novel and unusual channels of expression were driven by his ravenous desire for information and his unquenchable yearning for adventure.

Williams's time at the Juilliard School in New York City, where he studied theater and developed his comedic and acting abilities, was one of the pivotal periods in his early career. Here, Williams's unbridled skill and improvisational genius really came to the fore, as he wowed teachers and pupils alike with his razor-sharp

humor, lightning-fast improvisations, and remarkable ability to play a wide range of roles.

Williams started a career in stand-up comedy after graduating from Juilliard, where he soon made a name for himself as one of the most fascinating and unexpected performers around. His distinct mix of physical comedy, observational humor, and quick improvisation wowed crowds and won him a lot of praise, which helped him make the move from stage to screen.

In the popular television sitcom "Mork & Mindy," Williams played the endearing extraterrestrial Mork, which served as one of the first examples of his genius to be seen on a national scale. When the program debuted in 1978, Williams's unmatched comic skills and unstoppable charisma were on full display, propelling him to fame almost immediately. His legendary depiction of the crazy alien with a golden heart, Mork, won over millions of fans and solidified his place among the most cherished and famous characters in television history.

From then on, Williams's career took off, and he became one of the most talented and adaptable performers of his time, starring in a number of successful blockbuster movies. Casting as a fast-talking radio jockey in "Good Morning, Vietnam," an ardent English teacher in "Dead Poets Society," or a devoted nanny in "Mrs. Doubtfire," Williams captivated viewers with his nuance, sincerity, and sensitivity.

Williams consistently reinvented himself throughout his career, pushing the limits of humor and narrative while asking viewers to see the world in novel and surprising ways. His relentless dedication to his profession, daring attitude to performing, and exceptional ability to embody a diverse spectrum of personalities distinguish him as a natural innovator and leader in the entertainment industry.

Behind the scenes, however, Williams faced inner demons and psychological problems that often threatened to destroy both his life and profession. He struggled with addiction, despair, and self-doubt despite his apparent success and fame; these issues led to his

untimely suicide in 2014. His death stunned the entertainment industry and sparked a global outpouring of sympathy and condolences from friends, family, and coworkers.

Williams's early flashes of genius take on a bittersweet poignancy after his passing, acting as a heartbreaking reminder of the incredible skill and compassion that the world lost much too soon. But his legacy endures because of his classic performances, his ongoing influence on popular culture, and the many people he touched with his kindness, generosity, and humor.

Birth and Family Heritage

The fascinating tale of Robin Williams' birth and family history provides context for comprehending the extraordinary life and career of one of the most well-liked performers of our day. Robin was raised in a household of varied and well-educated parents, and his early experiences had a profound impact on the development of his unique abilities and distinct personality.

Born in Chicago, Illinois, on July 21, 1951, Robin McLaurin Williams came from a household that

combined warmth, humor, and academic discipline. Robert Fitzgerald Williams, his father, had a demanding position as a senior executive at Ford Motor Company, which often caused the family to migrate. Strong work ethics and a severe manner were attributes of Robert Williams that Robin would later both struggle against and imitate in his own life. Conversely, Laurie McLaurin, Robin's mother, was a former model known for her vibrant personality and her talent for storytelling, which she shared with her son. Laurie's wit and Southern charm were essential in fostering Robin's sense of humor.

The legacy of Robin's family is a tapestry made from several social and cultural strands. Anselm J. McLaurin, his paternal great-grandfather, served as both the governor of Mississippi and a U.S. senator, demonstrating a history of civic engagement and social impact. Because of her relationship with well-known politicians, Robin was raised with a keen understanding of the complexity of the world. In the meanwhile, he was raised with a hint of European elegance and intellectual

curiosity due to his mother's French ancestry. Combining these various origins gave Robin a broader outlook and a greater understanding of other people's cultures and history. Early Robin's life was spent in the wealthy Illinois suburb of Lake Forest. Although the Williams family was comfortable, young Robin often found himself alone. Since his mother had social obligations that required her to travel often and work long hours, Robin was forced to spend a lot of time with the household maid. These alone hours were when Robin's vivid imagination really started to take off. He imagined a wide range of people and situations, showing signs of the improvisational creativity that would eventually characterize his work.

Because of Robert's work, the Williams family traveled a lot before settling in the San Francisco Bay Area. While the frequent moves exposed Robin to a range of cultural contexts, they also added to his feeling of alienation. He met new people and experienced diverse lifestyles in every location he moved to, which deepened his grasp of human nature and gave him a never-ending source of

fodder for his humorous remarks. Additionally, Robin's wandering existence helped him develop resilience and adaptability qualities that would come in handy in the capricious entertainment industry.

Though the family moved often, Robin took comfort in their extensive library. Because both of his parents supported education and intellectual development, Robin was raised in a setting that fostered a love of reading. He read voraciously on everything from science fiction and comedy to philosophy and history. This diverse range of interests stimulated his imagination and influenced his subsequent work, in which he skillfully combined slapstick comedy with intellectual allusions.

His education significantly influenced Robin's early growth. He was a standout student at the exclusive Detroit Country Day School, where he also found his love for theater. He was able to express his enthusiasm and imagination via school plays, which gave him a sneak peek at his exceptional skill. Robin's instructors' encouragement and the nurturing atmosphere at his

school enabled him to fully embrace his dramatic and humorous talents.

Robin came from a home where religion and relationships were complicated. He was exposed to the rituals of organized religion as well as the philosophical issues it raised throughout his upbringing in the Episcopal Church. Through his Catholic upbringing, Robin was first exposed to themes of morality, spirituality, and human connection that would recur in his writing. From the poignant monologues in "Dead Poets Society" to the philosophical reflections in "Good Will Hunting," Robin's performances often conveyed a profound reflection on life's most critical issues.

The contrast between his mother's free-spirited personality and his father's strict practicality became increasingly apparent as Robin got older. This dynamic conflict influenced his personality, encouraging a combination of inventiveness and discipline. Robin's developing skills were fostered by his mother's encouragement of creativity and his father's emphasis on hard work. He discovered a way to reconcile these

conflicting inspirations, which helped him develop his own style of performing.

Robin had a significant loss in 1987 at the passing of his father. Many of the nuances of their relationship came to light at that very introspective period. Robin always wanted to follow his own path, one that embraced laughter and pleasure instead of the corporate rigidity that had characterized Robert Williams's life, even if he had always valued his father's praise. During this introspective time, Robin was able to completely accept the comic brilliance that was intended for him and get a deeper understanding of himself.

The combination of academic rigor, cultural depth, and intricate interpersonal dynamics found in Robin's family history served as the cornerstone for his remarkable career. A comic mythology was woven together by the influences of his parents, the lonely hours he spent developing his imagination, and the rich fabric of his ancestry. Millions of people were delighted, laughed, and gained deep insights from Robin Williams'

performances, which reflected the colorful and varied background from which he sprang.

Youthful Curiosity

One characteristic that set Robin Williams apart and provided the groundwork for his incredible career in comedy and acting was his insatiable curiosity as a child. His unquenchable curiosity, limitless creativity, and astute observation of the world around him signaled him as someone destined for greatness from an early age. His early years were marked by an unrelenting curiosity about the outside world and the inner workings of the human mind, which laid the groundwork for his eventual success as one of his generation's most popular and adaptable performers.

Williams was raised in a home that valued education and artistic endeavors. His mother, Laurie McLaurin, was a former model with a gift for storytelling, and his father, Robert Fitzgerald Williams, was a senior executive at Ford Motor Company. This combination of aesthetic

sensitivity and financial savvy produced a special atmosphere that fostered Robin's imagination and curiosity.

When he was younger, Robin had a keen interest in everything in his environment. His never-ending inquiries and eagerness to learn how things operated were clear indicators of his curiosity. His tendency of disassembling household appliances to examine their inner workings sometimes annoyed his parents but also demonstrated his mechanical curiosity and analytical thinking. His early interest in item mechanics was a prelude to his eventual capacity to dissect and comprehend the subtleties of human emotion and behavior.

Beyond the material world, Robin was also curious about concepts and tales. He read a great deal, devouring books on everything from science and history to mythology and fantasy. His parents' extensive collection of books became a haven where he could lose himself in other people's thoughts and realities. His extensive reading habit expanded his knowledge and stimulated his

creativity, creating a vast reservoir of material from which he would later draw for his tragic and humorous roles.

Robin's mother Laurie was one of the biggest impacts on his early interest. Little Robin was enthralled by her storytelling talent and lighthearted sense of humor, which encouraged him to hone his own storytelling abilities. Robin was deeply impacted by Laurie's captivating stories and her skill at accents and impersonations, and she enthusiastically took in and imitated her methods. His early exposure to the craft of character development and narrative was very influential in the development of his improvisational skills and humorous approach.

In addition to his mother's influence, Robin had further opportunity to develop his artistic abilities and curiosity throughout his school years. He did very well academically and was especially attracted to areas that enabled him to express his creativity. He attended prestigious institutions such as Detroit Country Day School and then Redwood High School in Larkspur,

California. His favorite courses were English and theater since they allowed him to pursue his passion for language, reading, and performing arts.

Robin started to have a more systematic interest about human nature throughout his high school years. He started participating in theatrical plays, which gave him a fresh Acting as a way for him to express his creativity. He gained a greater grasp of human emotions and relationships through acting, which enabled him to explore a variety of personalities and situations. His portrayals were distinguished by an exceptional capacity for character empathy, a quality that would come to define his career. Both teachers and students were aware of his extraordinary gift and often expressed amazement at his capacity to authentically and nuanced bring people to life.

Because of his unquenchable curiosity, Robin also ventured outside of his house and place of education. He was fascinated with people and enjoyed studying how they behaved. He would often spend hours observing and imitating the voices and movements of people in

parks or crowded streets. His ability to imitate and convey the essence of a broad spectrum of characteristics and personalities was sharpened by this practice of acute observation. His unique capacity to change into nearly anybody or anything would eventually be shown in his stand-up comedy and cinematic work, which is a tribute to his intense curiosity about human nature.

Even with his developing skills, Robin faced obstacles on his road to success. Because of his father's work, he was often relocated, which required him to adjust to new situations and develop new acquaintances constantly. Although this should have been frustrating, Robin's innate interest made it a chance to discover other people's cultures and ways of life. With every relocation, he gained fresh experiences and material for his humorous repertoire, which expanded his comprehension of the complex web of human existence.

Robin's path of inquiry and discovery took a dramatic shift after high school when he enrolled in the political science program at Claremont Men's College. But soon, his love of acting and his unquenchable curiosity forced

him to move to the College of Marin, where he enrolled in the theater department. This choice was a turning point in his life since it gave him the opportunity to devote himself entirely to the performing arts. His teachers were quick to see his extraordinary skill and urged him to pursue acting further.

Because of his early interest, Robin was admitted to the esteemed Juilliard School in New York City, where well-known professors, including John Houseman, taught him. Robin's enormous energy and unquenchable need for knowledge found a supportive atmosphere at Juilliard. He flourished in the very demanding environment, developing his skills and broadening his creative horizons. His time at Juilliard was characterized by a deep investigation of various acting styles, character development, and improvisation, all of which laid the foundation for his success in the future.

Robin Williams's early curiosity served as a catalyst for his artistic pursuits throughout his life. His unwavering quest for knowledge, comprehension, and discovery enabled him to consistently reinvent himself and push

the limits of his craft. Together with his acute observational abilities, quick wit, and capacity to draw from a broad variety of experiences and emotions, he was a unique and remarkable performance.

Education and Early Dreams

Robin Williams's upbringing and childhood aspirations serve as a testimony to the transformational potential of creativity, curiosity, and pursuing one's hobbies. Williams's journey reflects the convergence of intellectual rigor, artistic exploration, and a relentless drive to bring joy and insight to audiences worldwide. It begins with his formative years in a succession of elite educational institutions and ends with his aspirations and eventual achievements in the world of performance.

Being raised in a wealthy family, Robin was exposed to a multitude of educational chances and resources that influenced his creative and intellectual growth.

Private schools were Robin's first educational experiences, where his innate curiosity and intelligence were fostered. Due to his father's work, the family had to relocate often, which exposed Robin to a range of school settings and cultural experiences. This continual shift widened his views and encouraged adaptation, which was both a struggle and a benefit. Robin showed a strong desire to study from a young age. He would often lose himself in books and absorb information on a variety of topics.

Robin attended Detroit Country Day School, a prestigious private school renowned for its demanding academic program and focus on character development. It was one of his most influential educational experiences. Here, Robin was an outstanding student, especially in areas that let him use his imagination and natural curiosity. His love of reading and telling stories

grew, and he started to have a profound respect for the arts and literature.

Robin was initially introduced to the transforming potential of theater while attending Detroit Country Day School. By taking part in school plays and drama lessons, he found a new way to communicate with others and express his ideas. His creative energy and strong imagination found a home in the theater, where he could explore a variety of personalities and storylines. His instructors and classmates soon noticed his outstanding skill, and he started to stand out in school performances.

Following their time at Detroit Country Day School, the Williams family moved to Larkspur, California, where Robin enrolled at Redwood High School. During this time, he continued to explore and develop his artistic interests. Redwood High School provided a nurturing atmosphere that inspired Robin to explore his passion for acting more thoroughly. He kept becoming better at theater, taking part in a lot of school plays and earning a reputation for his captivating stage presence and improvisational abilities.

Robin's early aspirations were inspired by the cultural milieu of the 1960s and 1970s, a period marked by creative innovation and social turmoil, in addition to his academic education. The countercultural movements of the time, which placed a strong emphasis on creativity, self-expression, and questioning the status quo, had a profound impact on him. This cultural environment spoke to Robin's sense of rebellion and will to push limits in his artistic creations.

Robin first chose a more traditional route by enrolling at Claremont Men's College (now Claremont McKenna College) to study political science despite his burgeoning enthusiasm for performing. The expectations of his father and the social mores of the day, which often gave conventional job choices precedence over creative pursuits, had an impact on this choice. But it took only a short time to see that Robin's actual calling was somewhere else. He started looking for performance possibilities because of his endless curiosity and desire for artistic expression, and he quickly discovered that the theater was where he belonged.

Robin made the crucial choice to transfer to the College of Marin, a community institution with a robust theatrical department after realizing that political science was not his true passion. This shift changed his life, giving him the opportunity to devote himself entirely to the performing and acting industries. Robin's gifts blossomed at the College of Marin, where he was guided by committed teachers who saw his potential and pushed him to follow his goals.

Robin experimented and explored a great deal throughout his stay at the College of Marin. He immersed himself in his studies, mastering his skill and accepting complex parts in a variety of shows. His performances demonstrated his exceptional skill at encapsulating the complexity of the human experience, with comedy and sadness expertly blended. Here, Robin started honing the improvisational techniques that would eventually become his signature, mesmerizing audiences with his sharp wit and limitless inventiveness.

Inspired by his achievements at the College of Marin, Robin focused on enrolling in the Juilliard School in

New York City, one of the most esteemed schools for budding actors. Although it was intimidating to audition for Juilliard, Robin's hard work and innate skill paid off as he was admitted into the theater department. Juilliard was renowned for its demanding training curriculum and high standards of excellence. Thus, this was a noteworthy accomplishment.

Robin received instruction from well-known teachers at Juilliard, including John Houseman, who appreciated his extraordinary skill and urged him to embrace his approach. Robin was able to develop his improvisational skills while receiving a solid foundation in acting from the school's challenging curriculum and focus on classical training. Throughout his stay at Juilliard, he consistently improved his abilities and pushed himself to new limits in his quest for perfection.

Among the students Robin befriended during his time at Juilliard was Christopher Reeve, with whom he bonded deeply. These connections gave Robin a sense of community and support as he overcame the difficulties of his training. His time at Juilliard further solidified his

convictions about the healing potential of art and the value of sincerity in performance.

Robin's scholastic path was closely linked to his childhood aspirations. His career was characterized by a tireless pursuit of his hobbies, from his early infatuation with storytelling and performing to his formal schooling at some of the most prominent institutions. In addition to molding his creative talents, his school and theatrical experiences gave him a profound grasp of the human condition, which he would later apply to his work on stage and film.

After graduating from Juilliard, Robin started a career in stand-up comedy, which is where his childhood ambitions really started to take off. He soon distinguished himself on the comedy circuit with his distinct fusion of observational humor, improvisation, and character work, garnering him critical praise and a devoted fan base. His performances reflected the young curiosity and passion that had driven him throughout his life, with an unafraid readiness to push limits and explore new terrain.

CHAPTER 2

The Making of a Comedic Legend

This is the story of how someone with such incredible skill, limitless energy, and steadfast dedication to their profession can become a comedy icon like Robin Williams. Williams's career was characterized by a tireless pursuit of greatness, a profound connection with his audience, and a unique ability to merge comedy with compassion. This trajectory began in his early days as a young performer and continued through his rapid climb

to become one of the most popular comedians and actors of his time.

Due to his father's work, Robin had to move often throughout his early years, which gave him a rich tapestry of experiences and exposed him to a variety of cultures that would later influence his comic approach. Robin took comfort in his rich imagination and his capacity to make others laugh, even in the face of perpetual upheaval. He often used comedy to deal with loneliness and adjust to new situations, developing his impressionist and mimicry abilities in the process.

His formal schooling greatly aided Robin's growth as a performer. While attending elite educational institutions like Detroit Country Day School and Redwood High School in California, he demonstrated remarkable intellectual achievement and developed an ardor for theater. He had the opportunity to experiment with many characters and storylines via his involvement in school plays, which gave him a sneak peek into his unique gift. His instructors and colleagues acknowledged Robin's remarkable talents, and he rapidly gained recognition for

his captivating onstage persona and adeptness in improvisation.

Following high school, Robin briefly attended Claremont Men's College to study political science, but he quickly discovered that acting was his true calling. He moved to the College of Marin to pursue a degree in acting, where he became fully involved in the theatrical community. His Marin teachers saw his promise and pushed him to go after his goals, which led to his trying out for the renowned Juilliard School in New York City. Robin's life changed when he was accepted into Juilliard's theater division, where he received intense instruction and the chance to hone his skills.

Robin studied at Juilliard under the tutelage of well-known teachers, including John Houseman. The rigorous curriculum at the school placed a strong emphasis on improvisation and classical training, which helped Robin to hone his technique. He experimented and explored a great deal throughout his time at Juilliard, pushing the limits of his skills and broadening his creative horizons. Robin's progress as an artist was

fostered by the friendly and stimulating atmosphere offered by his other students, which included his close friend Christopher Reeve.

After graduating from Juilliard, Robin entered the stand-up comedy scene, where his exceptional skill immediately made him stand out. His fast-paced energy, lightning-fast improvisation, and fantastic ability to embody a variety of voices and personalities were all hallmarks of his performances. Because of his distinctive fusion of physical comedy, emotive narrative, and observational humor, Robin gained a devoted following and received a great deal of praise from the public. In his stand-up performances, he attacked a broad range of themes with humor, intelligence, and irreverence, showcasing his daring approach to comedy.

1978 saw Robin's big break when he was chosen to play the endearing extraterrestrial Mork in the popular television sitcom "Mork & Mindy." Robin became an instant celebrity when his program, a spin-off from an episode of "Happy Days," demonstrated his unmatched comic skills and unstoppable charisma. His legendary

depiction of Mork—an eccentric alien with a golden heart—won over millions of fans and solidified his place among the most cherished characters in television history. The way that Robin was able to combine poignant moments with slapstick humor turned "Mork & Mindy" into a sensation that captivated audiences and made Robin a comedy powerhouse.

With the popularity of "Mork & Mindy," Robin made a move to the big screen, where his acting depth and flexibility never ceased to wow viewers. His cinematic career was distinguished by a number of iconic performances that demonstrated his ability to strike a balance between drama and humor, often imbuing his characters with a deep sense of humanity. Robin's first Academy Award nomination came from his 1987 appearance in "Good Morning, Vietnam," when he played the irreverent radio DJ Adrian Cronauer. His depiction of Cronauer, a person who turned to comedy to get through the horrors of war, illustrated Robin's capacity for humor even in the most dire situations.

With a series of highly regarded performances in the late 1980s and early 1990s, Robin cemented his standing as One of the most versatile performers of his time. He portrayed the inspirational English instructor John Keating in "Dead Poets Society" (1989), whose nontraditional teaching methods inspired his pupils to grab the day and embrace their uniqueness. The movie's catchphrase, "Carpe diem," became a cultural reference point, and both reviewers and viewers found great resonance in Robin's emotional portrayal.

In movies like "Awakenings" (1990), in which he played Dr. Malcolm Sayer, a doctor who finds a revolutionary treatment for catatonic patients, and "The Fisher King" (1991), in which he played a homeless man seeking redemption, Robin's skill at balancing comedy and drama was further demonstrated. These parts demonstrated Robin's extraordinary versatility as an actor and his ability to give his characters nuance and realism.

Alongside his dramatic roles, Robin maintained his comedic skills, giving standout performances in movies

like "Aladdin" (1992) and "Mrs. Doubtfire" (1993), in which he voiced the joyful and endearing Genie and played a father who poses as a nanny in order to be near his kids. His improvisational skill in "Aladdin" was especially remarkable, as Robin gave the Genie a flurry of energy and a variety of accents, turning him into one of the most adored animated characters ever.

DDespite his achievements, Robin's trip was challenging. He publicly spoke about his issues, including struggles with addiction and depression, in interviews and through his art. Because he often relied on his weaknesses to connect with his characters and his audience, these experiences gave his performances an additional dimension. Robin's persistence and unshakable dedication to his art were shown by his ability to find comedy and optimism despite tragedy.

Critical and financial success were hallmarks of Robin's subsequent career. His portrayal of Dr. Sean Maguire in "Good Will Hunting" (1997) earned him his first Academy Award for Best Supporting Actor, demonstrating his capacity to communicate deep insight

and compassion. Robin received universal acclaim for his performance as Maguire, a therapist who helps a disturbed young prodigy find his way, and this role cemented his reputation as a great actor. It was regarded as one of his best roles to date.

Over the course of his career, Robin Williams consistently sought out new challenges and pushed the limits of his ability, demonstrating his dedication to his profession. His work was distinguished by an unwavering desire to make people laugh and think, a courageous willingness to take chances, and a strong sense of empathy for his characters. Audiences all throughout the world are still inspired and amused by Robin's incalculable contributions to the comedy and entertainment industries.

First Steps in Comedy

When Robin Williams took his first steps in comedy, it marked the start of an incredible journey that would make him one of the greatest and most adored comedians of all time. His extraordinary combination of innate skill, unwavering determination, and an unquenchable curiosity in human nature paved the way for his rise to comedy fame. During this rigorous time of research and discovery in his early years, Robin refined his technique and started To establish the unique style that would come to define his career.

Robin had a natural ability to keep people entertained. Robin was enthralled with Laurie McLaurin's storytelling talent and lighthearted sense of humor. His early training in storytelling and imitation would later prove to be essential to his comic arsenal.

His formal schooling greatly influenced Robin's comic instincts. He participated in school plays and theater workshops at Detroit Country Day School and then at Redwood High School in California, where he fell in

love with performing. His creative energy and strong imagination found a home in the theater, where he could explore a variety of personalities and storylines. His professors and friends instantly noticed his gift for improvisation and his ability to make others laugh.

Following high school, Robin studied political science for a short while at Claremont Men's College. But his real love was acting, so he quickly switched to the College of Marin to pursue a degree in theater. Here, Robin's comedic abilities really started to take off. He became fully involved in the theatrical industry, accepting complex parts and honing his improvisational abilities. His performances demonstrated his exceptional skill at encapsulating the complexity of the human experience, combining comedy and tragedy most extraordinarily.

Robin experienced rapid personal development and self-discovery throughout her stay at the College of Marin. His teachers inspired him to try out for the renowned Juilliard School in New York City, where he was admitted into the theater department. Robin studied

at Juilliard under the tutelage of well-known teachers, including John Houseman. The rigorous curriculum at the school placed a strong emphasis on improvisation and classical training, giving Robin a strong foundation in acting.

Even with the rigorous training at Juilliard, Robin's passion was always for the improvised and capricious realm of stand-up comedy. His quick wit and innate ability to improvise made him an ideal choice for the comedy circuit. After finishing Juilliard, Robin relocated to San Francisco, a city renowned for its thriving comedy Culture. Here, he started his career as a professional comedian.

During the 1970s, San Francisco was a center for innovative art and countercultural groups. The diverse range of influences present in the city offered Robin an ideal environment for his humorous inquiry. He began doing performances at neighborhood clubs like Holy City Zoo, a cozy, modest space that served as a testing ground for his budding career. Robin had a unique capacity to connect with his audience and performed

with a frenzied intensity. His erratic and improvised manner soon won him a reputation, and his fast-paced delivery and absurd personas often left audiences in stitches.

Robin started to get inspiration from a variety of places as he worked to improve his skills. Great comedians of the day, such as Lenny Bruce, Jonathan Winters, and Richard Pryor, whose innovative work pushed the frontiers of humor and social satire, affected him. The daringness with which Robin approached a broad range of subjects, from politics and social concerns to the follies of daily life, was evident in her performances. His distinctive voice in the comedy industry was developed by his ability to combine humor with perceptive insights, which distinguished him from his contemporaries.

Due to his early success in the San Francisco comedy scene, Robin was able to go to Los Angeles and start doing stand-up at the famous Comedy Store. Many of the most well-known comedians of the day got their start at The Comedy Store, and Robin's performances immediately took audiences. Industry insiders were

drawn to his high-energy performances and improvisational genius, which helped him get his big break on television.

Robin was chosen to play the endearing extraterrestrial Mork in the 1978 television sitcom "Mork & Mindy." When Mork made his debut in a "Happy Days" episode, he became an immediate favorite with viewers. Through his characteristic improvised manner and inexhaustible energy, Robin portrayed the quirky alien, turning "Mork & Mindy" into a global sensation. With the help of the program, Robin was able to show off his humorous skills to a broader audience, which resulted in positive reviews and a devoted following.

A turning point in Robin's career was "Mork & Mindy," which made him a household celebrity and gave him access to new possibilities in television and movies. But even with his small-screen success, Robin never lost his love for stand-up comedy. He kept doing performances in theaters and clubs, honing his material and developing his skills. Robin's stand-up acts were known for their

ingenuity and spontaneity, as he often improvised quickly, generating a flurry of voices and characters.

One of the secrets to Robin's success was his ability to establish a very intimate connection with his audience. Sincere warmth and empathy permeated his comedy, enabling him to approach weighty subjects with elegance and charm. Whether touching on societal concerns, inner challenges, or life's oddities, Robin's performances struck a chord with viewers, making them laugh and inspiring introspection.

As his career took off, Robin started to go to the big screen, where he gave a number of well-regarded performances. Movies like "Dead Poets Society," "Good Morning, Vietnam," and "Mrs. Doubtfire" demonstrated his acting range and his capacity to combine humor with pathos. Through these roles, Robin was able to develop his skills further and further cemented his place among the most adored and esteemed actors of his time.

Even after enjoying success in movies and television, Robin never wavered from his stand-up comedy

foundations. He kept on touring and doing live performances, entertaining audiences all over the globe with his brand of comedy. Critics praised his stand-up specials, "Robin Williams: Live on Broadway" and "Weapons of Self-Destruction," which solidified his reputation as a master of the genre.

Breakthrough on the Small Screen

A significant turning point in Robin Williams's remarkable career was his small-screen debut, which catapulted him from a budding young comic into a household celebrity and cultural legend. His first role on this trip was as the endearing extraterrestrial Mork in the TV program "Mork & Mindy," where he demonstrated his unique ability and distinct comic style. In addition to propelling Williams to fame, the program changed the face of comedy on television in the late 1970s and early 1980s.

Williams's journey to fame on television was anything from typical. His fast-paced energy, lightning-fast improvisation, and versatility garnered the attention of industry insiders when he honed his technique at stand-up comedy clubs in Los Angeles and San Francisco. His status as a rising star in the comedy industry was cemented by his appearances at illustrious locations like the Comedy Store in Los Angeles.

A pivotal moment in Williams's career occurred when he was chosen to play the extraterrestrial character Mork from the planet Ork in a classic comedy episode called "Happy Days." In the 1978 episode "My Favorite Orkan," the character made his debut. Audiences were instantly captivated by Mork's eccentric ways, innocent curiosity, and charming catchphrases like "Nanu Nanu" and "Shazbot." Williams's performance was a masterwork of improvisational genius, fusing a strong sense of humanity with whimsical charm, physical humor, and physical comedy.

Because of the episode's popularity, "Mork & Mindy," a spin-off series, was developed and debuted on September 14, 1978. The program chronicled the travels of Mork, a robot brought to Earth to investigate human behavior, and his connection with Mindy McConnell, a grounded young lady portrayed by Pam Dawber who serves as his mentor through the complexities of everyday life. A wealth of hilarious moments were created by the relationship between Mork and Mindy, whose naïve misinterpretations of human conventions

and Mindy's patient explanations laid a rich comedy basis.

Williams's captivating acting played a significant role in "Mork & Mindy"'s rapid rise to fame. His performance of Mork was distinguished by an endless supply of energy and an extraordinary capacity for improvisation. He often strayed from the script to add impromptu comedy to sequences. Because of this spontaneous flexibility, Williams was able to display his comic instincts, turning mundane situations into hilarious treasures.

Thanks to the program's style, Williams has the ideal platform to showcase his comic repertoire. In every episode, Mork navigates life's many facets, from relationships and dating to employment and social mores, all the while reporting hilarious stories about Ork to his superiors. Williams's skill at blending slapstick comedy, clever language, and poignant moments into various circumstances made "Mork & Mindy" an exceptional success.

Williams's use of physical humor made "Mork & Mindy" one of the show's most memorable elements. He stood out from his contemporaries with his ability to execute intricate physical jokes, spectacular pratfalls, and twist his body into exaggerated stances. This physicality, together with his quick wit and talent for mimicking, made Mork a memorable character and demonstrated Williams's range as an actor.

The influence of "Mork & Mindy"'s popularity on Williams's career was significant. During the four seasons of the program, which aired from 1978 to 1982, Williams gained widespread recognition. He received praise from critics for his depiction of Mork, and in 1979, he was awarded the Golden Globe for Best Actor in a Television Series Musical or Comedy. Due to the show's success, merchandising sales skyrocketed and included catchphrase-heavy record albums, comic novels, and action figurines of Mork.

Beyond the awards and financial success, "Mork & Mindy" gave Williams a stage on which to use humor to explore more profound subjects. The concept of the

program allowed for a unique examination of human nature, often making observations on biases, cultural conventions, and the absurdities of contemporary life from Mork's outsider viewpoint. The program gained depth from Williams's ability to strike a mix between comedy and profound social criticism, which connected with viewers on many levels.

Despite its popularity, "Mork & Mindy" had difficulties during its existence, such as modifications to the show's creative direction and changes in the television industry. Numerous retoolings were made to the program, including changes to the cast and adjustments to the structure and tone. These modifications ultimately resulted in the show's demise in 1982, along with varying ratings. Still, "Mork & Mindy" left a lasting impact, as fans continued to laud the program for its inventiveness and Williams's legendary performance.

It is impossible to overestimate the influence of "Mork & Mindy" on Williams's career. In addition to making him a household name in comedy, the program gave him access to other networks and roles in movies and

television. Williams's popularity on television easily transferred to the big screen, where he was able to demonstrate his range as an actor further. His portrayal of a masterful balancing act in films like "Good Morning, Vietnam," "Dead Poets Society," and "Mrs. Doubtfire" cemented his place among the most remarkable actors of his time.

Williams continued to be dedicated to his stand-up comedy origins while pursuing a career in movies. He carried on doing live performances, entertaining audiences all over the globe with his brand of comedy. His critically acclaimed stand-up specials, "Robin Williams: Live on Broadway" and "Weapons of Self-Destruction," demonstrated his ongoing capacity to engage audiences with comedy.

Williams's success on the small screen had a long-lasting effect on the comedy genre as a whole. His improvisational manner inspired a generation of comedians and writers and a desire to push limits, which opened the door for more avant-garde and unusual sitcom and comic programming techniques. The comic

Robins Williams 2024

ideas of Williams and Mork & Mindy are responsible for the success of shows like "The Simpsons," "Seinfeld," and "Curb Your Enthusiasm."

CHAPTER 3

Conquering Hollywood

Hollywood was conquered by Robin Williams, a monument to his incredible skill, adaptability, and unwavering determination. Williams's career in show business began with his stand-up comedy days and continued with a string of ground-breaking performances that demonstrated his unique ability to combine humor

with deep emotional resonance. Today, he is regarded as one of the most cherished and respected performers in the business. His enduring effect on the craft of acting and filmmaking was just as significant to Hollywood as his financial success.

In the late 1970s and early 1980s, Williams started making the switch from television to movies when he was still the lead actor in the popular television series "Mork & Mindy." His first significant motion picture appearance was in Robert Altman's "Popeye," which debuted in 1980. Williams, who embodied the legendary cartoon sailor with his trademark mix of humor and physical comedy, took the title role. Despite the fact that reviewers gave "Popeye" varying reviews, Williams's performance was highly appreciated for showcasing his ability as a movie actor and alluded to the flexibility that would characterize his career.

Williams proceeded to play a variety of parts after "Popeye," which gave him the opportunity to showcase other aspects of his skill. He appeared in the 1982 film "The World According to Garp," which was adapted

from a John Irving book. Williams demonstrated his ability to handle serious material with depth and empathy in his depiction of T.S. Garp, a writer navigating the complexity of life and relationships. The movie was favorably praised and was a turning point in Williams's development as a serious performer.

But the movie "Good Morning, Vietnam" from 1987 was the one that really made Williams a household name in Hollywood. Williams plays radio DJ Adrian Cronauer, who provides irreverent comedy and rock 'n' roll to American soldiers in Vietnam. Barry Levinson is the film's director. Williams's improvisational abilities were ideal for the part that allowed him to deliver moving and amusing rapid-fire monologues. His portrayal cemented his image as an influential artist capable of striking a balance between humor and depth and garnered him his first Academy Award nomination for Best Actor.

The popularity of "Good Morning, Vietnam" made Williams eligible for a number of enduring parts that would come to define his career. He played one of his favorite roles in "Dead Poets Society," as John Keating,

which he appeared in in 1989. The film, which Peter Weir directed, narrates the tale of an English teacher who encourages his pupils to "seize the day" and accept who they are. Williams's depiction of Keating was profoundly affecting and encouraging; it also earned him a second Academy Award nomination and solidified his reputation as a versatile actor who can provide strong performances.

Williams kept viewers enthralled with a string of iconic movies that demonstrated his breadth and skill throughout the 1990s. He portrayed Dr. Malcolm Sayer, a neurologist who finds a way to briefly revive catatonic patients, in the 1990 film "Awakenings." Williams was able to portray a great deal of empathy and sympathy with his quiet, caring portrayal. Williams's ability to play serious parts was shown in this highly praised picture, which also featured Robert De Niro.

Williams's mastery of comedy was evident in movies such as "The Birdcage" (1996) and "Mrs. Doubtfire" (1993). Williams portrayed Daniel Hillard in "Mrs. Doubtfire," a film about a divorced father who poses as

an old British nanny in order to spend more time with his kids. Williams's performance, which was lauded for its heart, humor, and deftly blended melancholy and comedy, helped make the movie a critical and economic triumph. In Mike Nichols' "The Birdcage," Williams portrayed drag nightclub owner Armand Goldman alongside Nathan Lane. Williams's depiction of Armand in the amusing and poignant film was a masterful comic performance, demonstrating his ability to give even the most ridiculous characters nuance.

Williams had a significant impact on animated movies in addition to live-action ones, most known for his work as the voice of the Genie in Disney's "Aladdin" (1992). Williams had a fantastic improvisational performance as the Genie, imbuing the role with a great deal of humor and fire. He was able to use all of his comic skills in the part, and the final product was a performance that was both very charming and incredibly amusing. Williams's Genie became one of the most adored characters in animated cinema history as "Aladdin" became an enormous hit.

Williams's flexibility was further shown in movies such as "Good Will Hunting" (1997), in which he portrayed Dr. Sean Maguire, a therapist who assists Matt Damon's character, a troubled young prodigy, in finding his life's purpose. Williams gave a nuanced, sensitive, and very human depiction of Maguire in the play, which was a change from his humorous beginnings. Williams's ability to provide emotionally charged performances in a variety of genres is shown by the Academy Award he received for Best Supporting Actor for his performance.

Williams continued to play a variety of parts throughout the late 1990s and early 2000s, including dark comedy and psychological thrillers. He portrayed a medical student using humor to treat patients in "Patch Adams" (1998), and he had a spooky performance as a lonely photo technician who becomes fixated on a family whose images he develops in "One Hour Photo" (2002). These parts further cemented Williams's standing as one of Hollywood's most versatile performers by showcasing his willingness to take chances and experiment with many facets of his profession.

Despite his accomplishments, Williams struggled personally, battling despair and addiction. These difficulties gave his performances an additional level of complexity since he often used his weaknesses to relate to both his characters and his viewers. Williams's fortitude and constant devotion to his profession were shown by his ability to find comedy and optimism in the face of hardship.

Williams had a more significant influence on Hollywood than just his roles. He was well renowned for his friendliness and generosity, often going above and above to assist other performers and staff members. His charitable endeavors included backing issues like education, human rights, and homelessness. Williams left behind a magnificent collection of work, but his legacy is also judged by the good influence he had on those around him and the profession at large.

Williams had several outstanding performances in his latter years, such as his parts as Teddy Roosevelt in "Night at the Museum" (2006) and President Dwight D. Eisenhower in "The Butler" (2013). His ability to

provide a broad variety of characters, realism, and nuance made him a popular figure in Hollywood until his tragic death in 2014.

1980s Success

The 1980s saw a sea change in Robin Williams's career, turning him from a cherished TV personality into a significant player in Hollywood. His ability to combine humor and drama so well allowed him to play a variety of parts, making him one of the most versatile performers of his time. During this time, he gave a number of memorable performances that demonstrated his depth, breadth, and unique ability to engage audiences.

Following the 1978 debut of his television program "Mork & Mindy," Robin Williams entered the 1980s with a strong sense of achievement. Williams portrayed the endearing extraterrestrial Mork from the planet Ork in the series, which shot to fame. He won over millions of fans with his depiction of Mork, which was

characterized by frantic energy, improvisational genius, and a strong sense of compassion. Williams became well-known throughout "Mork & Mindy's" run, which lasted until 1982. In 1979, he was awarded a Golden Globe for Best Actor in a Television Series – Musical or Comedy.

With "Mork & Mindy" coming to an end, Williams started to gain traction in the film business. His first significant motion picture appearance was in Robert Altman's "Popeye," which debuted in 1980. Williams embodied the legendary cartoon sailor with his trademark mix of humor and physical comedy, taking the title role. Williams's performance in "Popeye" drew accolades for its charm and genuineness despite the film's mixed reviews, which showed Williams's promise as an actor.

Based on the John Irving book, Williams's true cinematic breakthrough was "The World According to Garp," released in 1982. Williams portrayed writer T.S. Garp, a man negotiating the intricacies of relationships and life. His portrayal in this movie demonstrated his ability to

handle sensitive and nuanced dramatic material. "The World According to Garp" marked Williams's triumphant move from television to the big screen, as both reviewers and viewers praised the movie.

Williams gave some of his most iconic performances in the late 1980s, beginning with "Moscow on the Hudson" (1984). In this movie, Williams portrayed Soviet circus Musician Vladimir Ivanoff, who defected to the US. His genuine and very human performance of Ivanoff won him praise from critics and solidified his reputation as a gifted actor.

Williams appeared in the 1987 movie "Good Morning, Vietnam," which would go on to become a pivotal point in his career. Williams plays radio DJ Adrian Cronauer, who provides irreverent comedy and rock 'n' roll to American soldiers in Vietnam. Barry Levinson is the film's director. Williams's ability to improvise was well shown in the part, which allowed him to give moving and amusing rapid-fire monologues. His act was a masterful fusion of humor, social satire, and a profound feeling of humanity. "Good Morning, Vietnam" was a

critical and financial hit that cemented Williams's place in Hollywood history and led to his first Academy Award nomination for Best Actor.

Williams further showcased his dramatic versatility in 1989's "Dead Poets Society," in which he portrayed unconventional English teacher John Keating, encouraging his pupils to "seize the day" and accept their Uniqueness. Peter Weir, the film's director, created a cultural icon, and Williams gave an incredibly poignant and inspiring performance. His performance of Keating, which combined passion, insight, and sensitivity, earned him a second Academy Award nomination and solidified his reputation as a significant and versatile actor.

Williams performed stand-up comedy throughout the 1980s, exhibiting his unmatched improvisational abilities and lightning-fast wit. He was able to assume a broad variety of personas and voices, and his stand-up performances were known for their frantic intensity. He released a number of popular comedic albums during this time, including "Reality...What a Concept" (1979), which took home the Grammy for Best Comedy Album.

Williams's stand-up routines served as evidence of both his devotion to the craft of comedy and his ongoing rapport with live audiences.

Williams had success in stand-up and movies, but he was also involved in many other endeavors that demonstrated his flexibility and breadth of talent. He voiced characters in animated films, made dramatic television film appearances, and persisted in accepting challenging assignments that stretched the limits of his abilities. He showed his dedication to his work and drive to pursue new creative directions by taking on a variety of genres and subjects.

Williams's success in the 1980s was determined by more than only his box office performance and critical praise; it also included his enduring influence on the entertainment sector. His skill at fusing comedy with intense emotional depth redefined the bar for comic actors and affected a whole generation of actors. Williams's roles in movies such as "Dead Poets Society" and "Good Morning, Vietnam" show that humor might

be an effective way to explore severe subjects and establish a deeper connection with viewers.

For Robin Williams, the 1980s were a decade of development and change characterized by a number of ground-breaking performances that highlighted his extraordinary skill and adaptability. From his early breakthrough in "Mork & Mindy" to his highly regarded parts in "Good Morning, Vietnam" and "Dead Poets Society," Williams showed that he could enthrall audiences with a mix of drama and humor. He had a significant influence on the cinema business, establishing a new benchmark for humorous performers and permanently altering the course of culture. Williams's work in the 1980s set the stage for an outstanding career that would inspire and amuse audiences for decades to come as he continued to develop as an artist.

1990s Golden Era

Few periods in Hollywood's colorful history light as brightly as the 1990s, and within its dazzling fabric, one star shone more brilliantly than the rest: Robin Williams. During what might rightfully be called his "Golden Era," Williams rose to unprecedented heights after emerging from the comic shadows of the 1970s and 1980s.

Williams' career took a dramatic shift in the 1990s when his unbridled talent went beyond genre and media boundaries, solidifying his place as one of the most

endearing and adaptable performers of his time. His notable performances in movies like "Good Morning, Vietnam" and classic comedies like "Mork & Mindy" had already shown his comic skill and dramatic nuance, but it was the 1990s that really showed off the extent of his range.

Williams began the decade with a bang, co-starring with Robert De Niro in "Awakenings" (1990), where he played a moving depiction of a psychiatrist testing out a novel therapy for patients who were catatonic. He received great praise for this portrayal, which also paved the way for ten iconic performances that would forever change the film industry.

Williams had perhaps one of his most famous roles in 1991, as the wacky genie in Walt Disney's classic animated film "Aladdin." His unparalleled energy and improvisational abilities gave the genie life, transforming him into a timeless representation of comic genius. The movie's success demonstrated Williams' ability to fascinate audiences of all ages and cemented his position as a box office juggernaut.

Williams showed off his flexibility as the decade went on, moving between drama and humor with ease and playing characters that varied from heartbreaking to endearing. He played a Scottish nanny in "Mrs. Doubtfire" (1993), where he spent time with his kids and had heartfelt moments with them, along with jokes. The film's examination of family relationships connected with viewers further demonstrated Williams' talent for fusing comedy with a moving narrative.

In "Dead Poets Society" (1989), Williams played an unusual English teacher who encouraged his pupils to enjoy the day and follow their interests. This role showcased Williams' theatrical skills. His portrayal of the character struck a profound chord with viewers, garnering him critical praise and an Academy Award nomination for Best Actor.

Williams kept pushing the envelope and defying expectations in the second half of the decade by taking on parts that demonstrated the breadth of his acting abilities. In "Good Will Hunting" (1997), he had a complex role as a counselor who assists a disturbed

young prodigy in facing his history and realizing his destiny. Williams' ability to authentically and deeply embody complex characters is shown by the Academy Award for Best Supporting Actor he received for the part, which was his only win.

Williams' impact was felt in a variety of media outlets outside of film, such as stand-up comedy specials and television guest spots that had a lasting impression. He became a mainstay of late-night talk shows and comedy circuits because of his unmatched improvisational abilities and quick wit captivated audiences with his contagious energy and scathing humor.

Nevertheless, Williams battled addiction and despair throughout his life, in addition to his demons, in the middle of laughter and adulation. Sadly, his hardships came to an abrupt end in 2014, and he left behind a legacy that still motivates and inspires people around him.

Looking back, the 1990s provide proof of Robin Williams' extraordinary brilliance and lasting influence.

Williams' Golden Era continues to be a bright light of inventiveness and humor in a world that is constantly changing, thanks to his legendary performances and his enduring influence on popular culture. We are reminded of the ability of laughter to bring people together, heal, and cross barriers as we consider his incredible career. And in that laughter, Robin Williams continues to exist, imprinted in the hearts and minds of those who were impacted by his unique spirit for all time.

The 2000s and Beyond

Through the 2000s and beyond, Robin Williams' career served as a tribute to his lasting skill, unshakable dedication to his craft, and his tremendous influence on audiences all over the globe. Williams kept captivating audiences with his wide variety of performances as the new century got underway, flitting between comedy and drama with ease and making a lasting impression on every project he worked on.

Williams demonstrated his comic skills in the early 2000s with roles in movies like "Patch Adams" (1998) and "Death to Smoochy" (2002), bringing his signature wit and irreverent comedy to the big screen. Williams played a physician in "Patch Adams," treating his patients with compassion and humor. His portrayal was a funny mix of genuine emotion and hilarity. In "Death to Smoochy," on the other hand, he performed as a disgraced presenter for children's television, displaying his ability to portray strange and fantastical characters.

But Williams's real distinction at this time was his tragic parts. He had a melancholic performance in the 2002 film "One Hour Photo" as a lone photo technician who develops a deadly obsession with the family whose images he takes. The movie demonstrated Williams' capacity to embody nuanced and ethically gray roles, and he received praise from critics for his terrifying performance.

Williams persisted in pushing limits and defying expectations in parts that demonstrated his range as an actor. Acting alongside Al Pacino as a crafty and manipulative crime author in "Insomnia" (2002), he gave a performance that had viewers on the edge of their seats. Being able to authentically and deeply embody morally complicated characters solidified his reputation as one of Hollywood's most esteemed performers.

Williams' career took off as the decade went on, thanks to parts that highlighted his depth and breadth as an actor. With a nuanced portrayal that won him significant praise, he played a radio program presenter who becomes entangled in a mystery surrounding a little child

and his guardian in "The Night Listener" (2006). Williams, on the other hand, portrayed a father in the 2009 film "World's Greatest Dad" who uses his son's terrible death to his advantage in order to become famous and successful. Williams gave a darkly humorous portrayal that demonstrated his ability to merge comedy with social critique.

Through his work in other mediums, Williams continued to inspire and motivate viewers thus his impact went beyond the silver screen. Thanks to his quick wit and contagious enthusiasm, Williams became a revered character in popular culture, appearing in everything from his classic stand-up comedy specials to his unforgettable guest appearances on television series. His charitable endeavors, which included using his position to promote issues important to his heart, such as mental health and children's charities, won him admirers from all over the globe.

But despite his fame and admiration, Williams battled addiction and melancholy all of his life due to personal issues. Sadly, his battles came to an end in 2014, and he

left behind a legacy that still impacts viewers all over the globe. Following his departure, both coworkers and admirers honored Williams' extraordinary gift and giving nature, honoring the love and laughter he provided to the world.

Thinking back on Robin Williams' incredible career serves as a reminder of the ability of laughter to bring people together, heal, and cross barriers. His enduring performances, charitable work, and the many lives he enriched with compassion and charity all serve to perpetuate his legacy. Even though he is no longer with us, Robin Williams will always be regarded as one of the greatest performers of all time and as a bright example of compassion and creativity in a changing world.

CHAPTER 4

The Man behind the Laughter

Beyond the roles he played in cinema, Robin Williams was a complicated, varied person whose life was filled with both sorrow and accomplishment. Beneath the comedy and exaggerated exterior was a guy who battled deep internal issues while utilizing his gift and sense of humor to make millions of people happy all around the globe.

Williams was raised in a loving household that fostered his inventiveness and sense of humor. He had a natural gift for humor from an early age, often surprising his friends and family with his sharp wit and impressions. Despite having a natural sense of humor, Williams battled emotions of insecurity and self-doubt and turned to comedy as a coping strategy to get through the difficulties of puberty.

Following his studies in drama at New York City's Juilliard School, Williams developed his skills on the stand-up comedy circuit, where he soon became a rising sensation. His intense passion, lightning-fast delivery, and remarkable talent for embodying a diverse array of personas enthralled spectators and garnered him a loyal fan base. Williams' comic style, which combined irreverent humor with perceptive insights about the human condition, started to take shape during this period.

Williams' big break came in 1978 when he was paired with the endearing extraterrestrial Mork in the popular TV show "Mork & Mindy." Williams shot to fame

overnight, enthralling audiences with his outrageous antics and limitless charm. The popularity of the program made him a household name and set the stage for a successful career spanning many decades.

Williams became known as one of Hollywood's most adaptable performers in the 1980s and 1990s, showcasing his extraordinary skill and variety in parts that straddled the comedy and drama genres. Williams enthralled moviegoers with his ability to embody a broad variety of characters with depth and sincerity, from the exuberant genie in Disney's "Aladdin" to the inspiring English teacher in "Dead Poets Society."

Williams battled addiction and despair throughout his life, even in the middle of celebrity and wealth, despite his professional achievements. He battled emotions of isolation and loneliness behind closed doors, turning to booze and narcotics to dull the agony. Williams found himself caught in a cycle of addiction that threatened to engulf him despite his repeated efforts at recovery.

Williams bravely decided to get treatment for his addiction and check himself into a rehab facility in 2006. It was a pivotal moment in his life, the start of a path toward healing and self-awareness. Williams addressed the underlying problems that drove his addiction, including a lifetime battle with depression, through treatment and contemplation.

Williams' struggle with depression opened a broader discussion on mental health awareness and destigmatization by shedding focus on the often misdiagnosed and stigmatized illness. He was open and honest about his experiences in interviews, encouraging those who were facing mental illness to get assistance and care.

Williams was committed to using his gift and position to inspire others and change the world, even in the face of personal adversity. He was committed to philanthropy throughout his life, sponsoring several nonprofits that promoted topics including the arts, education, and children's health. Numerous people were impacted by his

warmth and compassion, which left a long-lasting legacy of empathy and goodwill.

Sadly, the world was horrified to learn about Robin Williams' premature passing on August 11, 2014. Beloved comedian and actor took his own life, leaving behind a bereaved family, friends, and hordes of admirers worldwide. People throughout the world expressed their sorrow and gratitude for the loss of a tangible symbol and cultural treasure, which was the cause of his demise.

Following his passing, there was a renewed focus on mental health and suicide prevention as a way to pay tribute to Williams by de-stigmatizing these topics and increasing public awareness of them. His passing was a sobering reminder of the toll mental illness can take and the need to get support and assistance when needed.

Thanks to his classic performances, charitable work, and the many people he touched with his compassion and humor, Robin Williams' legacy continues to this day. Even though he is no longer with us, his spirit lives on in

us, encouraging and uplifting us to laugh, love the people in our lives, and never be scared to ask for assistance when we need it most. Even while he may not have been Robin Williams will impact the source of the laughter, generations to come.

Personal Life Unveiled

Not only was Robin Williams a highly acclaimed actor and comic genius, but he was also a complicated person whose personal life often reflected the highs and lows of his work. Beneath the humor and the spectacular exterior was a guy battling deep inner conflicts and looking for purpose and connection in his interactions with friends, family, and other loved ones.

Robin McLaurin Williams, born July 21, 1951, in Chicago, Illinois, was reared in a middle-class family with his two half-brothers, Robert Fitzgerald Williams

and Laurie McLaurin. Williams had an early propensity for creativity and performance, often amusing his family with his sharp wit and impersonations. Williams was raised in a loving and caring family by his mother, a former model, and father, a senior executive at Ford Motor Company, who encouraged him to follow his creative talents.

Even with his innate sense of humor, Williams had difficulties growing up. He battled emotions of uncertainty and self-doubt and often turned to comedy as a coping strategy to get through the challenging times of puberty. He had a fast wit and an irreverent sense of humor at school, but he also struggled with feelings of isolation and alienation.

Williams studied drama at the Juilliard School in New York City after graduating from Claremont Men's College in California. He refined his talent at Juilliard under the direction of famous acting instructor John Houseman, where he also developed his distinct humorous voice and improvisational abilities.

Williams' life drastically changed in 1976 when he was cast as the quirky alien Mork from the planet Ork in the popular television series "Mork & Mindy." Williams shot to fame overnight, enthralling audiences with his unbridled charm and frenetic intensity. The popularity of the program made him a household name and set the stage for a successful career spanning many decades.

Williams had a turbulent and turbulent personal life despite his success in his career. He battled addiction and despair all of his life, turning to booze and narcotics to dull the agony. He struggled with drug misuse for most of his adult life, which resulted in several hospital stays and disrupted friendships and familial ties.

Zachary was Williams' son from his first marriage, which he entered into in 1978 with Valerie Velardi. Despite their early happiness, Williams' rising success and the demands of fame had a negative impact on their marriage, which resulted in adultery and their 1988 divorce. Williams would later acknowledge that his battles with addiction contributed significantly to the dissolution of his marriage because he found it difficult

to reconcile his problems with his responsibilities as a parent and husband.

Williams married Marsha Garces, his second wife, in 1989. Garces had been Zachary's nanny. Zelda and Cody were the couple's two new arrivals, and they seemed to be happy together. But their marriage also had difficulties, such as Williams' continuous fight with addiction and Garces' difficulty managing her husband's unpredictable behavior.

Williams never wavered in his ferocious devotion to his kids, often listing being a parent as one of his greatest life pleasures. He loved spending time with his kids and fostering in them a passion for adventure, fun, and creativity. Williams prioritized being there for his kids despite his difficulties, fostering priceless moments that would last a lifetime.

Williams had emotional hardships in addition to physical issues later in life, such as heart surgery in 2009 and a Parkinson's disease diagnosis in 2013. Williams persevered in the face of these obstacles, pursuing his

love of humor and acting with elegance and steadfast resolve.

Sadly, the world was shocked to learn about Robin Williams' premature passing on August 11, 2014. Beloved comedian and actor took his own life, leaving behind a bereaved family, friends, and hordes of admirers worldwide. His passing stunned the entertainment world and provoked a global outpouring of condolences and remembrances.

Following his demise, Williams' family and friends spoke out about his battles with addiction and depression, bringing attention to these often misdiagnosed and stigmatized illnesses. His passing was a sobering reminder of the toll mental illness can take and the need to get treatment and assistance.

Thanks to his classic performances, charitable work, and the many people he touched with his compassion and humor, Robin Williams' legacy continues to this day. Even though he is no longer with us, his spirit lives on in us, encouraging and motivating us to treasure the people

in our lives, laugh heartily, and never be scared to ask for assistance when we need it most. Though Robin Williams had a multitude of skills, his generosity, compassion, and unshakeable spirit were what really made him stand out.

Battles and Triumphs

Robin Williams' life story is replete with setbacks and victories, demonstrating the human spirit's tenacity and the ability of humor to prevail over hardship. Williams had several difficulties throughout his career, ranging from health problems and professional losses to personal battles with addiction and despair. Nevertheless, he overcame hardship by remaining strong and encouraging others with his skill and sense of humor.

Williams' continuous fight with addiction was one of his most well-known struggles. Williams struggled with substance misuse for a large portion of his adult life, using drink and drugs as a coping mechanism for the demands of his profession and the expectations of celebrity. His drug problems would often show up as unpredictable conduct and damaged friendships and family ties, which resulted in many stays in treatment facilities and intervals of abstinence interspersed with relapses.

Williams never shied away from facing his issues and getting treatment for his addiction, despite the difficulties he encountered. He used his position to spread awareness of the risks associated with drug usage and was transparent and honest about his issues, sharing candidly about his experiences in interviews. Williams put in a lot of effort in therapy and treatment to beat his addiction and take back control of his life.

Williams' persistent battle with depression was another obstacle to overcome. Williams struggled with misery, loneliness, and despair for a large portion of his life,

often turning to comedy to cover up his inner suffering. His bouts of melancholy would often worsen during times of upheaval in his personal and professional life, leaving him feeling helpless and depressed.

Williams often had a severe feeling of loneliness and isolation despite his apparent prosperity and popularity. His public demeanor and personal troubles were difficult for him to reconcile, and he often felt as though he was leading two different lives. In 2014, he tragically committed himself as a result of his struggle with depression, leaving behind a bereaved family, friends, and admirers worldwide.

However, Robin Williams also had victories and moments of victory in the middle of his difficulties. Williams had a lasting impact on the entertainment industry with his memorable performances in movies like "Good Morning, Vietnam," "Dead Poets Society," and "Good Will Hunting," in addition to his breakout role as the endearing extraterrestrial Mork in "Mork & Mindy." His distinct fusion of charm, humor, and sensitivity won him over to audiences of all ages and

brought him many accolades and critical praise throughout the course of his career.

Williams' flexibility as an actor was shown by his ability to switch between humor and drama with ease, giving him the capacity to portray a broad variety of roles with depth and sincerity. Williams had a unique ability to elicit strong emotional responses from audiences, whether he was making them laugh with his improvisational prowess and quick delivery or bringing them to tears with his poignant performances.

Williams was a devoted humanitarian and philanthropist who used his wealth and notoriety to improve the world, in addition to his accomplishments on film. He was a lifelong supporter of several philanthropic organizations and causes, such as the arts, education, and children's health. Numerous people were impacted by his warmth and compassion, which left a long-lasting legacy of empathy and goodwill.

Notwithstanding the difficulties he encountered, Robin Williams' legacy endures thanks to his classic

performances, charitable work, and the many people he brought joy and compassion to. Even though he is no longer with us, his spirit lives on in us, encouraging and motivating us to treasure the people in our lives, laugh heartily, and never be scared to ask for assistance when we need it most. Even though Robin Williams had his share of struggles, future generations will remember his victories.

CHAPTER 5

Accolades and Applause

In addition to his remarkable skill and adaptability on screen, Robin Williams' remarkable career was shaped by the many honors and ovations he was showered with over his lifetime. Williams received a great deal of praise and recognition for his services to the entertainment industry, which included emotional tributes and significant prizes. His impact on both viewers and critics was permanent.

Williams developed an impressive resume of accolades and nominations throughout his career, solidifying his place among Hollywood's most renowned actors. Critics praised him for his ability to switch between humor and drama, exceptional improvisational abilities and moving performances.

In 1997, Williams won the Academy Award for Best Supporting Actor for his performance as Dr. Sean Maguire in the movie "Good Will Hunting." This was one of Williams' most significant accomplishments. He received a lot of respect and appreciation from his colleagues in the business for his moving depiction of a therapist who assists a disturbed young prodigy in facing his past and realizing his potential. Williams showed his humility and gratitude for the recognition in his acceptance speech, which was a touching ode to the film's creators, Matt Damon and Ben Affleck, as well as his fellow candidates.

Williams was nominated for three more Academy Awards throughout his career, in addition to his 1987 Oscar, for his roles in "Good Morning, Vietnam" (1987),

"Dead Poets Society" (1989), and "The Fisher King" (1991). Even though he did not win in these categories, his nominations demonstrated his extraordinary skill and influence on the film industry.

Williams received acclaim from other institutions and business groups in addition to the Academy Awards. He was honored with four Golden Globes, one of which was for his legendary performance as the gregarious genie in Disney's "Aladdin" (1992). He won over viewers of all ages with his ability to inject comedy and compassion into the cherished character, garnering him great praise and distinction from the Hollywood Foreign Press Association.

Williams was nominated many times by groups, including the Screen Actors Guild, the British Academy of Film and Television Arts, and the Primetime Emmy Awards, in addition to his Golden Globe victories. His remarkable work on screen garnered him accolades and critical praise for his roles in movies including "Patch Adams" (1998), "The Birdcage" (1996), and "Mrs. Doubtfire" (1993).

Beyond accolades and nominations, Williams' influence on popular culture was immense, as both colleagues and fans praised his brilliance, compassion, and humor. He became well-known in the comedy industry because of his sharp wit and contagious energy, and he developed a devoted fan base that appreciated his distinct comic style and charismatic presence.

Williams made major contributions to theater, stand-up comedy, animation, cinema and television, but his impact went beyond these media. His well-known voice roles in animated movies like "Aladdin" and "Happy Feet" (2006) demonstrated his range as a performer and his capacity to immortalize characters through his unique voice and witty timing.

Williams used his platform to raise awareness of significant social problems and causes that were near to his heart while remaining gracious and modest in the face of success. His humanitarian endeavors, including his collaborations with institutions like Comic Relief and St. Jude Children's Research Hospital, won him admirers

globally and had a long-lasting influence on the underprivileged.

Williams was awarded the coveted Mark Twain Prize for American Humor in 2009, an accolade given to those who have significantly influenced the comedy industry. In his speech to receive the prize, Williams discussed his career and the pleasure he had in making others laugh.

Even after his tragic death in 2014, fans all over the globe are still drawn to Williams' legacy and celebrate his life and work by attending memorials, retrospectives, and screenings of his most cherished movies. His contribution to the entertainment industry and his ongoing effect on popular culture are proof of his brilliance, inventiveness, and the joy he offered to millions of people over the course of his life.

Academy Awards

The Academy Awards, sometimes known as the Oscars, are the highest accolade in the film industry, given to the best actors and filmmakers. Numerous gifted people have starred in films throughout the years, making a lasting impression on the business and putting their names in the annals of Hollywood history. Among these icons is the legendary Robin Williams, who received global praise and Academy Award honors for his remarkable skill and memorable performances.

Williams' path to the Oscars was paved with a number of memorable parts and exceptional performances that demonstrated his range as an actor and his capacity to enthrall viewers with his own brand of heart and comedy. In 1987, he made his debut as Adrian Cronauer in the movie "Good Morning, Vietnam," which led to his first Academy Award nomination for Best Actor.

Williams played a charming and irreverent DJ in "Good Morning, Vietnam," who shook up the airwaves during the Vietnam War and cheered the troops stationed abroad. His act was a humor and improvisational masterclass that won him praise from critics and thrust him into the public eye as one of Hollywood's most promising newcomers.

Despite not receiving an Oscar for his performance in "Good Morning, Vietnam," Williams' nomination cemented his place in the industry as a top performer and opened the door for more Academy Awards honors. Three more Oscar nominations would come Williams' way over his career, all of which attested to his extraordinary skill and range of performances.

Williams was nominated for a second Academy Award in 1989 for his portrayal of the inspiring English teacher John Keating in the film "Dead Poets Society." In the Peter Weir-directed movie, which tackled issues of independence, creativity, and pursuing goals, Williams gave a subtle and poignant performance that both audiences and reviewers found to be quite moving.

Acting pro-Williams's interpretation of John Keating was a master lesson, combining knowledge, compassion, and comedy in equal measure. He received a lot of attention and was nominated for his second Academy Award for Best Actor because of his ability to encourage and inspire his children via poetry and storytelling, which won over the hearts of people everywhere.

Williams was nominated for a third Oscar in 1991 for his performance in "The Fisher King" as Parry, a destitute man seeking atonement. Under Terry Gilliam's direction, the picture explored love, sorrow, and the strength of human connection in a tragic and strange way. Williams gave a performance that was both heartbreaking and incredibly compelling.

Williams embodied sensitivity and resiliency in the role of Parry, garnering him praise from critics and a nomination for his third Academy Award for Best Actor. His performance as Parry demonstrated his flexibility as an actor and his ability to embody nuanced and emotionally taxing parts with genuineness.

Williams had been nominated before, but it wasn't until 1998 that he would eventually win the Academy's highest honor—an Oscar for Best Supporting Actor. The movie "Good Will Hunting," which was written and directed by Gus Van Sant and starred Matt Damon and Ben Affleck, brought him great recognition.

Williams portrayed Dr. Sean Maguire in "Good Will Hunting," a therapist who assists a disturbed young genius in facing his past and realizing his destiny. His performance was a surprise, striking a deep chord with both reviewers and fans by skillfully fusing comedy, empathy, and unadulterated passion.

Williams's performance as Dr. Sean Maguire, which brought him tremendous praise and his first Academy

Robins Williams 2024

Award, was a career-defining event. Williams showed his humility and gratitude for the recognition in his acceptance speech, which was a touching ode to the film's creators, Matt Damon and Ben Affleck, as well as his fellow candidates.

Apart from his Oscar victory, Williams' career was marked by a plethora of other honors and recognitions, such as two Primetime Emmy Awards, four Golden Globe Awards, and a Grammy Award for Best Comedy Album. His brilliance, humor, and kindness were praised by colleagues and fans alike, leaving an incalculable imprint on the entertainment industry.

Even after his tragic death in 2014, fans all over the globe are still drawn to Robin Williams' legacy and celebrate his life and work by attending screenings of his most cherished movies, retrospectives, and memorials. His Oscar nominations and victories attest to his brilliance and his long-lasting influence on the film industry, guaranteeing that his good humor and infectious personality will always be remembered.

Golden Globes, Emmys, and Grammys

The Academy Awards, sometimes known as the Oscars, are the highest accolade in the film industry, given to the best actors and filmmakers. Numerous gifted people have starred in films throughout the years, making a lasting impression on the business and putting their names in the annals of Hollywood history. Among these icons is the legendary Robin Williams, who received global praise and Academy Award honors for his remarkable skill and memorable performances.

Williams' path to the Oscars was paved with a number of memorable parts and exceptional performances that demonstrated his range as an actor and his capacity to enthrall viewers with his brand of heart and comedy. In 1987, he made his debut as Adrian Cronauer in the movie "Good Morning, Vietnam," which led to his first Academy Award nomination for Best Actor.

Williams played a charming and irreverent DJ in "Good Morning, Vietnam," who shakes up the airwaves during the Vietnam War and cheers the troops stationed abroad.

His act was a humor and improvisational masterclass that won him praise from critics and thrust him into the public eye as one of Hollywood's most promising newcomers.

Despite not receiving an Oscar for his performance in "Good Morning, Vietnam," Williams' nomination cemented his place in the industry as a top performer and opened the door for more Academy Awards honors. Three more Oscar nominations would come Williams' way over his career, all of which attested to his extraordinary skill and range of performances.

Williams was nominated for a second Academy Award in 1989 for his portrayal of the inspiring English teacher John Keating in the film "Dead Poets Society." In the Peter Weir-directed movie, which tackled issues of independence, creativity, and pursuing goals, Williams gave a subtle and poignant performance that both audiences and reviewers found to be quite moving.

Acting pro Williams's interpretation of John Keating was a master lesson, combining knowledge, compassion, and

comedy in equal measure. He received a lot of attention and was nominated for his second Academy Award for Best Actor because of his ability to encourage and inspire his children via poetry and storytelling, which won over the hearts of people everywhere.

Williams was nominated for a third Oscar in 1991 for his performance in "The Fisher King" as Parry, a destitute man seeking atonement. Under Terry Gilliam's direction, the picture explored love, sorrow, and the strength of human connection in a tragic and strange way. Williams gave a performance that was both heartbreaking and incredibly compelling.

Williams embodied sensitivity and resiliency in the role of Parry, garnering him praise from critics and a nomination for his third Academy Award for Best Actor. His performance as Parry demonstrated his flexibility as an actor and his ability to embody nuanced and emotionally taxing parts with genuineness.

Williams had been nominated before, but it wasn't until 1998 that he would eventually win the Academy's

highest honor—an Oscar for Best Supporting Actor. The movie "Good Will Hunting," which was written and directed by Gus Van Sant and starred Matt Damon and Ben Affleck, brought him great recognition.

Williams portrayed Dr. Sean Maguire in "Good Will Hunting," a therapist who assists a disturbed young genius in facing his past and realizing his destiny. His performance was a surprise, striking a deep chord with both reviewers and fans by skillfully fusing comedy, empathy, and unadulterated passion.

Williams's performance as Dr. Sean Maguire, which brought him tremendous praise and his first Academy Award, was a career-defining event. Williams showed his humility and gratitude for the recognition in his acceptance speech, which was a touching ode to the film's creators, Matt Damon and Ben Affleck, as well as his fellow candidates.

Apart from his Oscar victory, Williams' career was marked by a plethora of other honors and recognitions, such as two Primetime Emmy Awards, four Golden

Globe Awards, and a Grammy Award for Best Comedy Album. His brilliance, humor, and kindness were praised by colleagues and fans alike, leaving an incalculable imprint on the entertainment industry.

Even after his tragic death in 2014, fans all over the globe are still drawn to Robin Williams' legacy and celebrate his life and work by attending screenings of his most cherished movies, retrospectives, and memorials. His Oscar nominations and victories attest to his brilliance and his long-lasting influence on the film industry, guaranteeing that his good humor and infectious personality will always be remembered.

Critical and Popular Acclaim

Throughout his brilliant career, Robin Williams was a unique artist whose performances constantly won both critical praise and public devotion. Williams enthralled audiences with his incomparable humor, adaptability, and limitless energy from his early days as a stand-up comedian to his famous appearances on both the big and small screens. As a result, he received broad acclaim and recognition from both reviewers and fans.

Williams is among the most versatile performers in Hollywood because of his ability to switch between comedy and drama with ease. His early stand-up comedy work demonstrated his sharp wit, deft improvisational abilities, and irreverent sense of humor, which helped him gain a dedicated fan base that loved his distinct comic voice and larger-than-life presence.

Williams' variety of characters expanded along with his career, each new undertaking demonstrating his extraordinary breadth and depth as an actor. With roles in movies like "Good Morning, Vietnam," "Dead Poets

Society," and "Good Will Hunting," Williams proved he could handle complicated characters sensitively and nuancedly, winning him rave reviews and a slew of nominations and accolades.

Williams had a brilliant portrayal as the gregarious DJ Adrian Cronauer in "Good Morning, Vietnam," a role that makes troops stationed abroad in the war seem lighter and more fun. Critics praised his depiction of Cronauer in great detail, with many calling it one of his best performances to date.

An inspiring English teacher who exhorts his pupils to embrace the day and follow their goals, John Keating, is portrayed by Williams in "Dead Poets Society," which similarly enthralled spectators. Hailed as a triumph of heart and brain, his portrayal cemented his place as one of Hollywood's top actors and earned him a nomination for the Academy Award for Best Actor.

Williams' portrayal of Dr. Sean Maguire, a therapist who assists a disturbed young genius in facing his past and embracing his future, in "Good Will Hunting," defined

his career. His performance as Maguire was a master lesson in acting, a perfect fusion of empathy, comedy, and unadulterated passion that left an indelible impression on both reviewers and viewers. Williams's first Academy Award for Best Supporting Actor was given to him for the part, demonstrating both his skill and the influence he had on the movie.

Williams received a great deal of praise for his tragic parts, but he was just as well-liked for his comedy appearances, which demonstrated his unmatched capacity to make audiences laugh. With roles in movies like "Mrs. Doubtfire," "The Birdcage," and "Aladdin," Williams displayed his signature irreverence and wit, winning over hordes of admirers and cemented his place in comedy history.

With his depiction of Daniel Hillard in "Mrs. Doubtfire," Williams enchanted viewers as a divorced father who poses as a Scottish nanny to spend more time with his kids. He won a Golden Globe for Best Actor in a Musical or Comedy for his warm, funny, and nuanced performance, which was well received.

Similarly, Williams' depiction of Miami Beach drag club owner Armand Goldman in "The Birdcage" thrilled viewers. He received critical acclaim and a Golden Globe nomination for Best Actor in a Musical or Comedy for his sensitive and humorous timing in the role.

Williams was well-received both critically and popularly for his work in films as well as for his television roles. He was a famous comedy star on "Mork & Mindy" and had guest appearances on series like "Friends" and "The Larry Sanders Show." His signature humor and energy were evident in his television performances, which won him a devoted following and cemented his reputation as a comic great.

Williams' performances were distinguished by their depth, empathy, and unmistakable magnetic presence throughout his career. Williams had an uncanny capacity to connect with people on a highly emotional level, winning the respect and affection of both critics and fans. He could make audiences laugh with his quick wit

and contagious energy or move them to tears with his heartbreaking performances.

Williams was praised not just for his acting prowess but also for his charitable endeavors and dedication to utilize his position for good. Using his celebrity and wealth to change the world, he was actively engaged in a number of philanthropic causes and organizations, such as Comic Relief and St. Jude Children's Research Hospital.

Fans continue to celebrate Robin Williams' life and work via tributes, retrospectives, and screenings of his most cherished movies and TV series, even after his tragic death in 2014. His popularity and critical praise guarantee that his laugh and spirit will live on forever, and they are a monument to his brilliance, adaptability, and lasting influence on the entertainment industry.

CHAPTER 6

A Heart of Gold

The man known for his comic brilliance and acting skill on large and small screens, Robin Williams, had a golden heart that radiated well beyond the boundaries of Hollywood. Beneath his spectacular exterior was a kind and sympathetic heart, motivated by a deep-seated desire to cheer people up and ease their pain wherever he could. Williams has behind an enduring legacy of love

and compassion that uplifts and inspires many people with his deeds of kindness and generosity throughout his life.

Williams devoted his time, abilities, and money to several nonprofit causes and organizations over his extensive and influential philanthropic career. He was steadfast and deep in his dedication to changing the world, which ranged from encouraging environmental preservation and veterans' rights to helping children's hospitals and healthcare programs.

Williams has a special place in his heart for the health and welfare of children. He was actively engaged in a number of organizations throughout his life that aimed to better the lives of kids dealing with sickness, handicap, and misfortune. Williams made frequent visits to pediatric hospitals and treatment facilities, offering young children and their families comfort and joy during trying times.

One of his most prominent charitable endeavors was his participation with St. Jude Children's Research Hospital, a premier pediatric treatment and research center devoted to treating and curing children's ailments. Williams was known for spending hours at a time talking with patients at St. Jude, playing games, and telling jokes to cheer them up.

Williams sponsored groups like the Make-A-Wish Foundation, which grants wishes to kids with life-threatening illnesses, in addition to his work with St. Jude. He often took part in wish-granting rituals, going above and beyond—often at considerable personal sacrifice and inconvenience—to realize the wishes of kids with life-threatening diseases.

Beyond his philanthropic contributions, Williams' commitment to children's problems was shown by his role as an advocate and spokesman. He used his notoriety and power to bring attention to issues that concern kids, such as access to healthcare, education, and social services for the underprivileged. His fervent advocacy sparked a broader discussion on the

significance of making investments in the health and well-being of future generations and encouraged others to join the battle for children's rights.

Williams' charitable endeavors were complemented by a strong dedication to helping veterans of the armed forces and their families. Williams had a personal connection to the armed services and a great deal of respect for those who served their nation since he was the son of a veteran. He has always been actively engaged with groups like the United Service Organizations (USO), which offer entertainment and assistance to soldiers serving abroad.

Williams' regular trips to military installations and deployments abroad, where he delighted soldiers with his signature humor and contagious enthusiasm, demonstrated his commitment to helping veterans. He often engaged in meet-and-greet events and stand-up comedy performances with service personnel, providing them with a much-needed break from the demands of military life.

Williams' involvement in the USO's "Hope and Freedom Tour" in 2007—which took him to Iraq and Afghanistan to entertain soldiers stationed in combat zones—was one of his most treasured military experiences. His shows gave deployed military men who were distant from home a sense of humor and companionship while reaffirming that their efforts were valued.

Apart from his contributions to the causes of children and veterans, Williams was an enthusiastic supporter of environmental preservation and animal protection. He gave his support to groups that strive to save endangered animals and their ecosystems worldwide, such as the World Wildlife Fund and the Rainforest Foundation Fund.

Williams often expressed his profound admiration for the grandeur and beauty of the natural world, demonstrating his love of the outdoors and the natural world in his daily life. He was a passionate fly angler and environmentalist who used his position to spread the word about environmental problems and the need to protect the earth for the coming generations.

Williams' charitable endeavors demonstrated his sympathetic and caring personality and were motivated by a sincere desire to improve the lives of the less fortunate. His generosity and kindness impacted numerous people, and he left behind a loving and compassionate legacy that never ceases to elevate and inspire.

Williams was well-known for his charitable activities and sporadic gestures of generosity and compassion to those he met in his everyday life. His generosity had no boundaries, whether it was paying for a stranger's dinner, paying a fan's medical bill, or offering assistance to a needy person.

In 1997, Williams famously raised money for a buddy in need of a heart transplant by auctioning off his prized Harley-Davidson motorbike. This is one of the most well-known instances of Williams' charity. Williams demonstrated his desire to go above and beyond to assist people in need when he voluntarily surrendered the motorbike, despite his connection to it, in order to help save a life.

Robins Williams 2024

Williams, an actor renowned for his warmth, friendliness, and contagious humor, had a golden heart that showed in his interactions with friends, family, and coworkers. His quick wit, abundant energy, and genuine care for others were some of the ways he had a distinct aptitude for making others around him happy and bright.

The world lamented Williams' untimely passing in 2014 as a well-loved performer and humanitarian, but his legacy of kindness and love endures. Williams impacted the lives of many people with his charitable work and deeds, establishing a legacy of love and generosity that uplifts and inspires others to this day.

Charitable Ventures

The legendary actor and comedian Robin Williams was renowned for his boundless skill on stage and film, as well as his generosity and dedication to changing the world for the better. Over his life, Williams participated in several charity endeavors, promoting issues such as environmental preservation, veterans' rights, and children's health and education. His charitable endeavors demonstrated his profound understanding and compassion for other people, establishing a long-lasting legacy of generosity and kindness that now serves as an example to people all over the globe.

Williams was most passionate about a few subjects, including the health and welfare of children. He was strongly committed to helping organizations that treated sick, disabled, and underprivileged children medically and offered them assistance. St. Jude Children's Research Hospital, a premier pediatric treatment and research center devoted to treating and curing children's ailments, was one of the organizations he was most closely linked with.

Williams had a deep and personal connection to St. Jude. During his many trips, he spent time with the hospital's personnel, young patients, and their families. His visits brought the kids at St. Jude happiness and laughter, giving them a much-needed break from their medical procedures and a smile during trying times.

Williams helped St. Jude through a number of fundraising campaigns and events in addition to his trips. He participated in telethons, benefit concerts, and charity auctions, giving his time and skills to help the hospital generate money. In addition to providing vital assistance to the hospital and its patients, his generosity and dedication to the cause helped increase awareness of the significance of pediatric healthcare.

Beyond his involvement with St. Jude, Williams' commitment to children's health included several organizations and endeavors aimed at enhancing the well-being of children worldwide. He used his position to spread awareness of topics like children in need's

access to healthcare, nutrition, and education. He was a fervent supporter of children's rights and education.

Williams was involved with the charitable group Comic Relief, which was one method he helped children's education. Comic Relief generates money for a range of projects and organizations that assist children and families in need both domestically and internationally. Williams used his comic ability to help generate money for Comic Relief's charity endeavors by taking part in a number of events and fundraisers.

Williams supports educational projects meant to provide impoverished children chances for success in addition to his work with Comic Relief. He was a fervent supporter of arts education, seeing the transformational potential of the arts to ignite children's creativity, cultivate their capacity for critical thought, and advance their social and emotional growth.

One facet of Williams' charitable activities was his dedication to the health and education of young people. In addition, he had a strong enthusiasm for protecting the

environment and animals, fighting for the global preservation of endangered species and their habitats.

The Rainforest Foundation Fund, which aims to preserve rainforests and assist indigenous populations in South America and beyond, was one of the groups Williams funded in this regard. He actively supported the organization's goals and took part in campaigns and fundraising activities to increase public awareness of the value of rainforest protection.

Williams collaborated with many environmental groups, such as the World Wildlife Fund (WWF), which focuses on conservation efforts to safeguard endangered species and their ecosystems, in addition to his support for the Rainforest Foundation Fund. He provided his voice to a number of projects and initiatives that sought to conserve the environment for coming generations by bringing attention to environmental challenges and advocating for sustainable solutions.

Williams' commitment to protecting the environment was a reflection of his great love and admiration for the

natural world. He loved the great outdoors and was a fervent environmentalist. He loved to go hiking, camping, and fly fishing. He was motivated to take action to save the environment and spread knowledge of the value of maintaining natural ecosystems for the benefit of all living things by his connection to the outdoors.

A strong supporter of war veterans and their families, Williams also worked in the fields of education, environmental protection, and children's health. Williams had a personal connection to the armed services and a great deal of respect for those who served their nation since he was the son of a veteran.

Williams has always been a supporter of groups like the United Service Organizations (USO), which offers services, events, and entertainment to military personnel and their families all across the globe. Using his humorous gift to make soldiers serving far from home laugh and feel better, he often traveled to military stations and deployed service people abroad.

Williams' involvement in the USO's "Hope and Freedom Tour" in 2007—which took him to Iraq and Afghanistan to entertain soldiers stationed in combat zones—was one of his most treasured military experiences. His concerts offered solace and companionship to military personnel under threat, reassuring them that their efforts were valued and that they would not be forgotten.

Williams supported programs to prevent suicide and raise awareness of mental health issues in addition to helping veterans of the armed forces. He was candid about his own battles with addiction and despair, utilizing his experiences to highlight the need of getting treatment and assistance for mental health concerns.

Williams' support of mental health was a reflection of his empathy and compassion, as well as his goal to de-stigmatize mental illness and advance more acceptance and understanding. Because he thought that everyone should have access to high-quality mental health treatment, he devoted his life to supporting programs and organizations that aim to provide people in need of resources and assistance.

Robins Williams 2024

Through his humanitarian activities, Robin Williams showed a deep dedication to changing the world for the better throughout his life. Whether promoting the health and education of children

Champion of the Troops

Renowned performer Robin Williams, who was a devoted supporter of the armed forces, was renowned for his unmatched comic skill, contagious enthusiasm, and quick wit. Williams showed steadfast support for the men and women in the military services throughout his storied career, utilizing his celebrity and influence to cheer up service members stationed all around the globe. Williams grew up as the son of a military veteran, which contributed to his strong ties to the armed forces.

Williams often reminisced about his father's World War II service in the US Army and the principles of sacrifice, honor, and responsibility that were ingrained in him at an early age.

Williams recognized the sacrifices made by those who served their nation in order to preserve and uphold the liberties that all Americans take for granted, and as a performer, she felt a profound feeling of appreciation and respect for them. He often referred to it as the least he could do to demonstrate his gratitude for the soldiers' service and regarded it as a chance to give back.

Williams' regular trips to military installations, hospitals, and foreign deployments demonstrated his commitment to provide entertainment for the armed forces. Frequently at considerable personal cost and trouble, he made it his mission to provide humor and companionship to military personnel wherever they were stationed.

Williams collaborated closely with a number of groups, including the United Service groups (USO), a charity

that offers services, activities, and entertainment to military personnel and their families all around the globe. Williams was a devoted USO supporter who took part in many of the organization's tours and activities intended to amuse military men.

Williams' involvement in the USO's "Hope and Freedom Tour" in 2007—which took him to Iraq and Afghanistan to entertain soldiers stationed in combat zones—was one of his most memorable professional experiences. Williams was committed to providing a feeling of normality and happiness to military men who were far from home, despite the risks and difficulties that come with operating in a war zone.

Williams engaged in meet-and-greet events, showcased his stand-up comedy routines, and traveled to forward operating posts and military installations around Iraq and Afghanistan throughout the trip. His performances elicited laughter and raucous applause, giving military troops enduring the hardships of deployment a much-needed morale boost.

Williams' genuine kindness, humility, and gratitude for the soldiers' service were evident in his encounters with them throughout the trip. He made a lasting effect on everyone he encountered by taking the time to hear their tales, shake their hands, and express gratitude for their efforts.

Williams sponsored other organizations and programs that assisted military veterans and their families in addition to his work with the USO. He took part in awareness campaigns, charity auctions, and fundraising activities to generate money and support for veteran's causes, such as initiatives that aid injured soldiers and their caretakers.

Williams' dedication to helping the armed forces extended beyond his public persona and philanthropic pursuits. Additionally, he strongly promoted improved mental health services and assistance for veterans dealing with the unseen scars of war, such as traumatic brain injury (TBI) and post-traumatic stress disorder (PTSD).

Williams, who struggled with addiction and despair, recognized the need of getting support and assistance for mental health problems. Through his own experiences, he fought for more access to mental health resources and assistance for those in need, and he brought attention to the difficulties experienced by veterans returning from battle.

Williams' support of veterans' mental health was a reflection of his empathy and compassion, as well as his want to see that those who fought for their country were given the attention and assistance they were due. He had a deep belief in the ability of humor and companionship to mend emotional scars and foster fortitude in the face of hardship.

Williams received the Congressional Medal of Honor Society's covered Bob Hope Award for Excellence in Entertainment in 1998 in appreciation of his commitment to helping the armed forces. The award honored his unwavering efforts to provide happiness and humor to those who most needed it, and it acknowledged

Robins Williams 2024

his extraordinary services to elevate and amuse military personnel and veterans.

CHAPTER 7

The Twilight Struggle

A deep conflict, a twilight struggle, if you will, between the dark shadows of Robin Williams' inner problems and the dazzling light of his hilarious brilliance characterized his life. Beneath the smiles and giggles Williams made for millions of people worldwide, he struggled with deep grief, loneliness, and an unrelenting darkness that threatened to swallow him.

Williams, who was born in 1951, was raised in a wealthy Chicago suburb. He had a natural gift for comedy and acting from a young age, turning to humor as a coping technique to get through the difficulties of puberty and the demands of family expectations. His ability to make others laugh turned became his haven in a complex and intimidating world.

Williams' career took off in the 1970s and 1980s, and people all over the world started to recognize him for his unstoppable charisma, quick wit, and limitless energy. He garnered a devoted following and broad praise for his electric stand-up comedy routines, which he performed in popular television series like "Mork & Mindy" and which enthralled audiences.

Behind the scenes, however, Williams battled his own issues, including addiction, despair, and a crippling feeling of loneliness that followed him for the rest of his life. Williams struggled to reconcile the public persona of Robin Williams with the inner suffering of the guy hiding behind the mask, even in the face of his apparent

success and fame. Williams often felt alienated and uncomfortable in his own skin.

Williams used booze and narcotics as a coping mechanism for his inner anguish throughout his life, taking solace in the momentary forgetfulness they offered. But no matter how hard he tried to push away the agony, the darkness always seemed to find a way back, strangling him with its stifling grasp like a shadow at nightfall.

Williams's battle with addiction came to a peak in the early 1980s when he checked himself into treatment for the first time in order to face his demons. Williams had to confront the truth about his addiction and the toll it was having on his life and career. It was a time of reckoning, a moment of truth.

Williams seemed to find comfort in sobriety for a while, embracing a fresh perspective and sense of direction as he set out on a path of self-awareness and recovery. However, the darkness was always around, ready to strike again by hiding in the shadows.

Williams battled his inner demons in the years that followed, experiencing episodes of anxiety and despair that almost overwhelmed him. In an attempt to drown out the cacophony of his own thoughts with the scream of the audience, he took solace in his job and threw himself into his performances with a zeal and intensity that verged on obsession.

But despite his greatest attempts, the gloom persisted and hung over Williams' life and profession for a considerable amount of time. His existential thoughts tormented him late into the night as he struggled with emotions of inadequacy, self-doubt, and deep grief.

Williams maintained his sense of humor and his capacity to laugh even in the most dire circumstances throughout it all. Despite the darkness's imminent danger to consume him, he utilized humor as a lifeline. His performances evolved into a kind of therapy, a means of overcoming his inner demons and finding some measure of tranquility in an otherwise chaotic and harsh environment.

Robins Williams 2024

Williams' battle with alcohol and melancholy in his latter years came to a devastating end when he committed himself in 2014. Millions of admirers mourned the loss of a cherished performer and a talented artist who had impacted their lives in ways they could never completely express after his death, which shocked the whole globe.

Williams left behind a legacy that has persisted after his passing, demonstrating the lasting power of humor and the resiliency of the human spirit. His battles with addiction and despair have spurred a larger discussion about mental health and the value of providing support and assistance to those in need.

Despite the tragic conclusion to Williams' twilight fight, his legacy endures in the pleasure and happiness he offered to millions of people worldwide. Even though he fought against darkness, in the end it was his light that shined the brightest, bringing light into the lives of everyone who had the honor of knowing him, even if only indirectly.

Health Battles

The renowned comedian and actor Robin Williams was well-known for his unmatched abilities on stage and television as well as for his mysterious and speculative health issues. Williams had a number of hardships with his physical and mental health throughout his life, which put his fortitude and perseverance to the test and eventually shaped the course of his professional and personal lives.

Williams's fight with addiction was one of his most visible health issues. Williams struggled with drug misuse during his early career, including addiction to cocaine and alcohol, which he subsequently explained as a self-medication strategy to deal with the demands of his work and the expectations of celebrity.

Williams' addiction reached a breaking point in 1982 when he checked himself into treatment for the first time after it had spun out of control in the late 1970s and early 1980s. It was a turning point in Williams' life when he faced his addiction head-on and started the protracted and difficult path to recovery.

Williams' struggle with addiction would recur throughout his life in spite of his best attempts, resulting in many stays in treatment facilities and intervals of abstinence interspersed by relapses. His two divorces and continued financial difficulties, among other personal concerns, often made his drug problems worse.

Williams struggled with addiction in addition to a number of physical health conditions that affected his

general wellbeing and standard of living. Williams had to take a leave of absence from work in order to concentrate on his recuperation after aortic valve replacement surgery in 2009.

Williams' life changed significantly after the successful operation, leading him to reassess his goals and modify his way of life to prioritize his health and well-being. To reduce stress and anxiety, he started eating better, exercising, and adding mindfulness and meditation to his daily routine.

Williams had physical and mental health problems in the years that followed, despite his attempts to put his health first. 2013 saw the diagnosis of Parkinson's disease, a progressive neurological condition that impairs mobility.

Williams was devastated by the diagnosis since he had previously spent a large portion of his life struggling with anxiety and despair. His pre-existing mental health issues were made worse by Parkinson's disease, which resulted in emotions of helplessness, despair, and overwhelming loss.

Williams' health struggles came to a head in the last months of his life in 2014, when he was battling the depressing effects of his persistent melancholy and the physical and psychological consequences of Parkinson's disease. Williams eventually gave in to his inner demons and committed himself at the age of sixty-three, despite the backing of his family, friends, and medical experts.

Millions of admirers were left in shock when they learned of Williams' passing; they were grieving the loss of a cherished performer and a talented artist whose presence and ability had had a significant impact on their lives. His passing also spurred a more general discussion on mental health and the value of support and assistance for those battling addiction and despair.

Williams left behind a legacy that has persisted after his passing, acting as a constant reminder of the impermanence of life and the significance of helping those in need. His battles with addiction and mental illness have increased compassion and understanding for those going through similar things, and his humor and

skill have Delighted and amused countless numbers of admirers worldwide.

At the end of the day, Robin Williams' health struggles served as a monument to both the complexity of the human condition and the resiliency and fortitude of the human spirit. Williams never lost his capacity to make people laugh and smile, even in the face of apparently insurmountable challenges. He left behind a legacy of love, humor, and compassion that endures even in the most challenging circumstances.

Enduring Spirit

More than simply an actor or comic, Robin Williams is a name that has a lasting impact on the annals of entertainment history. He was a force to be reckoned with, a tornado of skill, inventiveness, and unbounded enthusiasm. His unwavering spirit, ingrained in his very nature, shone in the shadows of our world's darkest corners and left a lasting impression on the hearts and minds of millions of people everywhere.

From his early days as a stand-up comedian, Williams had an amazing sense of comic timing and a unique knack for improvisation. His shows were incredible—a laugh-filled, emotional rollercoaster that left the audience gasping for air and demanding more. But he was different from his contemporaries in that, underneath the surface of his extravagant image, there was a depth of compassion and sensitivity.

Williams' tenacious quest for perfection, his unshakable dedication to his profession, and his unwillingness to be constrained by tradition were all examples of his lasting

spirit. He was a trailblazer and a pioneer who bravely explored the enormous breadth of human experience with an unquenchable curiosity and an unquenchable thirst for adventure. He stretched the frontiers of comedy and drama equally.

Williams made a lasting impression on the film industry with a variety of iconic roles that spanned from hilarious comedies to moving tragedies. These roles were a monument to his flexibility and his capacity to embody a broad range of characters with nuance and sincerity. In "Good Will Hunting," Williams portrayed a troubled therapist in the throes of despair, and in "Mrs. Doubtfire," he wore a prosthetic nose. Williams' performances were imbued with a unique authenticity and a profound sense of humanity that touched audiences on an intense emotional level.

Millions of people were captivated by Williams not just because of his acting prowess but also because of his unwavering spirit, contagious humor, and inexhaustible generosity of heart. Williams was more than simply a performer; he was a ray of light in a world too often

dominated by gloom, a constant reminder that happiness, love, and laughter can still exist even in the depths of despair.

Williams' life was not without hardships, despite his seeming prosperity and the love of admirers everywhere. Beneath the smiles and laughter, there was a guy fighting addiction, sadness, and a deep feeling of loneliness that threatened to overwhelm him. Williams, however, never lost sight of the fire that blazed inside him the spark of passion and inventiveness that propelled him ahead against all obstacles.

Williams' unwavering attempts to make others laugh and smile, even while he was having difficulties, were arguably the clearest example of his undying spirit. He was a regular fixture at medical facilities, homeless shelters, and military installations, utilizing his platform and notoriety to illuminate the most impoverished areas of society and to encourage people in need. His compassion and boundless generosity impacted the lives of many people, establishing an enduring legacy of love and goodwill that uplifts and inspires others to this day.

Robins Williams 2024

During his last years, Williams' unwavering resilience was put to the ultimate test. After receiving a Parkinson's disease diagnosis, a progressive neurological illness, he was forced to face his death and the uncertainty of what lay ahead. Williams, however, stayed unwavering in the face of this enormous obstacle, not allowing the darkness of his disease to snuff out the light that blazed within him.

The world was shocked to learn about Williams' untimely death in August 2014. The subsequent outpouring of condolences and tributes was evidence of his lasting legacy and enormous influence on the globe. Even though Robin Williams is no longer with us, his soul endures in the warmth of his performances, the joy in his movies, and the many people he touched with his unending kindness and compassion.

CHAPTER 8

A Tragic Farewell

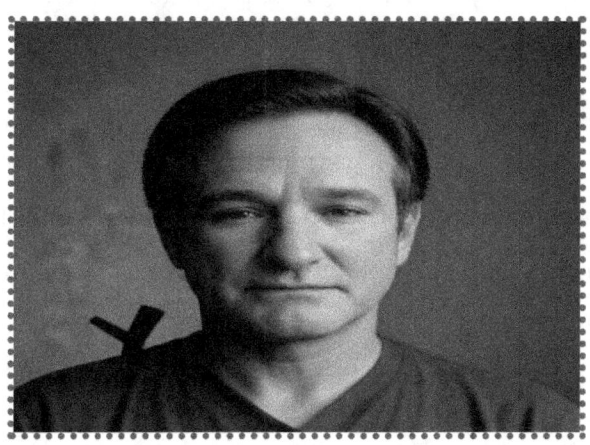

When word spread throughout the world in August 2014 of Robin Williams' heartbreaking goodbye, everyone stood in collective shock and despair. At the age of sixty-three, the adored comedian and actor, whose contagious laugh and inexhaustible energy had touched millions of lives, had suddenly taken his own life. Fans were in grief at the passing of a beloved performer and comic genius whose skill had shone in the darkest parts

of our planet as the news shocked Hollywood and beyond.

Williams passed away suddenly and unexpectedly, leaving many others to deal with intense grief, bewilderment, and disbelief. How could someone who had made so many people happy and laugh be overcome by such a deep darkness? Millions of people had this question gnawing at their hearts and minds—a menacing reminder of the complexity of the human condition and the frailty of life itself.

Following Williams' demise, condolences from fans, friends, and coworkers alike flooded in, honoring the man who had had such a profound impact on their lives. The outpouring of sadness, which included anything from poignant social media posts to candlelight vigils and spontaneous tributes, was evidence of the lasting legacy and significant influence that Williams left behind.

Williams' passing was a wake-up call for many, a sobering reminder of the value of mental health and the

need to de-stigmatize conversations about depression, anxiety, and suicide. The following days and weeks saw a resurgence of efforts to increase public awareness of the warning signs of mental illness and the significance of getting care and assistance for those who need it.

Williams' untimely death served as a poignant reminder that even the brightest stars are susceptible to darkness and that there is often a deep feeling of loneliness and suffering concealed beneath smiles and happiness. His passing spurred a broader discussion on the demands of popularity, its isolation, and the toll it may have on one's mental health.

Williams left behind a legacy that has survived throughout the years, serving as a constant reminder of the healing power of humor as well as the lasting effects of kindness and compassion. While his charity endeavors endure via the nonprofits he funded throughout his lifetime, his films continue to make people smile and laugh all across the globe.

Robins Williams 2024

Williams' heartbreaking departure serves as a painful reminder of the need to reach out to people in need and lend a sympathetic ear or a kind word to those who may be hurting in silence, even as we celebrate his life and legacy. It serves as a reminder that every one of us has a responsibility to elevate and encourage one another and to dismantle the stigma and shame that keep so many people from getting the treatment they need.

When word spread throughout the world in August 2014 of Robin Williams' heartbreaking goodbye, everyone stood in collective shock and despair. At the age of sixty-three, the adored comedian and actor, whose contagious laugh and inexhaustible energy had touched millions of lives, had suddenly taken his own life. Fans were in grief at the passing of a beloved performer and comic genius whose skill had shone in the darkest parts of our planet as the news shocked Hollywood and beyond.

Williams passed away suddenly and unexpectedly, leaving many others to deal with intense grief, bewilderment, and disbelief. How could someone who

had made so many people happy and laugh be overcome by such a deep darkness? Millions of people had this question gnawing at their hearts and minds—a menacing reminder of the complexity of the human condition and the frailty of life itself.

Following Williams' demise, condolences from fans, friends, and coworkers alike flooded in, honoring the man who had had such a profound impact on their lives. The outpouring of sadness, which included anything from poignant social media posts to candlelight vigils and spontaneous tributes, was evidence of the lasting legacy and significant influence that Williams left behind.

Williams' passing was a wake-up call for many, a sobering reminder of the value of mental health and the need to de-stigmatize conversations about depression, anxiety, and suicide. The following days and weeks saw a resurgence of efforts to increase public awareness of the warning signs of mental illness and the significance of getting care and assistance for those who need it. Williams' untimely death served as a poignant reminder

that even the brightest stars are susceptible to darkness and that there is often a deep feeling of loneliness and suffering concealed beneath smiles and happiness. His passing spurred a broader discussion on the demands of popularity, its isolation, and the toll it may have on one's mental health.

Williams left behind a legacy that has survived throughout the years, serving as a constant reminder of the healing power of humor as well as the lasting effects of kindness and compassion. While his charity endeavors endure via the nonprofits he funded throughout his lifetime, his films continue to make people smile and laugh all across the globe.

Williams' heartbreaking departure serves as a painful reminder of the need to reach out to people in need and lend a sympathetic ear or a kind word to those who may be hurting in silence, even as we celebrate his life and legacy. It reminds us that everyone has a responsibility to elevate and encourage one another and to dismantle the stigma and shame that keep so many people from getting the treatment they need.

Moral and lesson learned

The renowned comedian and actor Robin Williams left behind a vast collection of unforgettable sayings that uplift, amuse, and strike a chord with people everywhere. Williams' comments provide a glimpse into his sharp intellect and his distinct outlook on life, ranging from clever one-liners to profound insights into the human condition.

Williams's irreverent humor and sharp wit are best captured in one of his most well-known quotations: "You're only given a little spark of madness." You have to hold onto it." This passage expresses Williams' conviction that it's important to embrace one's peculiarities and oddities as well as the creative and individual spark that every one of us has. It serves as a gentle reminder to enjoy life's lighthearted and impromptu moments and to never lose sight of the magic that shapes who we are.

Williams is known for saying, "I think the saddest people always try their hardest to make people happy because they know what it's like to feel absolutely worthless, and they don't want anyone else to feel like that." This statement demonstrates Williams' profound empathy and compassion for others. This quotation highlights Williams' battles with addiction and sadness as well as his want to utilize his platform and skill to make other people laugh and smile. It serves as a moving reminder of the value of empathy and the need to help those in need.

Williams inspired millions of people with his insightful and wise comments throughout his life. His quotations continue to strike a chord with listeners of all ages and backgrounds, whether they are his thoughts on relationships and love or his observations on the human condition.

Williams' biography, which provides an insight into the highs and lows of his life and career, is a valuable resource in addition to his sayings. The need to get support and assistance while dealing with mental health

issues is among the most significant lessons we can learn from Williams' narrative. Williams battled addiction and despair for a large portion of his life despite his apparent success and notoriety. In 2014, he finally gave in to his inner demons. His untimely passing served as a devastating reminder of how critical it is to de-stigmatize conversations about mental illness and how important it is to put one's health and well-being first.

A further lesson that may be drawn from Williams' story is the significance of being genuine and loyal to oneself. Throughout his career, Williams defied social pressure to live up to others' expectations, instead pursuing projects that really appealed to him and his artistic impulses. Because of his willingness to take chances and embrace his voice, he is a living example of the value of authenticity and the need to be true to oneself in the face of difficulty.

Ultimately, reading Williams' life story serves as a reminder of how short life is and how important it is to treasure every second we spend with the people we care about. Williams' unexpected and shocking passing

stunned the whole world and devastated millions of people. It also served as a sobering reminder of how fleeting life is and how important it is to live each day to the fullest. His enduring performances, catchy sayings, and the many people he touched with his gift, generosity, and compassion all serve as testaments to his legacy.

www.ingramcontent.com/pod-product-compliance
Lightning Source LLC
Chambersburg PA
CBHW071501220526
45472CB00003B/880